Stocking
Stuffers

Stocking Stuffers

Homoerotic Christmas Tales

edited by
David Laurents

Circlet Press, Inc.
Cambridge, MA

Stocking Stuffers

Printed In Canada
ISBN 1-885865-42-2

First Printing September 2002

See Acknowledgments (p. 205-206) for individual permissions.

Circlet Press is distributed in the USA by SCB Distributors.
Circlet Press is distributed in the UK and Europe by Turnaround Ltd.;
Circlet Press is distributed in Australia by Bulldog Books.

For a catalog, information about our other imprints, review copies, and other information, please write to:
Circlet Press, Inc.
1770 Massachusetts Avenue #278
Cambridge, MA 02140
circlet-info@circlet.com
www.circlet.com

Contents

Introduction

David Laurents

This book is for all the boys on Santa's naughty list. It feels nice to be naughty sometimes and, as the characters in Lars Eighner's story learn, that act itself can be a present, to ourselves and each other.

Christmas is supposed to be a time of peace and happiness, of being with family and loved ones; the reality of Christmas is often a bit more frantic and claustrophobic, as what began as a celebration of Christ's birth has become a season of consumption and consumerism. There is no way to avoid the manic shopping frenzy that descends everywhere: as early as October, Christmas sales begin, and the game of

guessing and double-guessing what everyone you know wants, countered by musings about what they intend to buy for you (which will guide how much you spend on them) begins. Even if you are not hunting for bargains and that perfect present (the last of which is about to be snatched up by someone else) you can't avoid the congestion of shoppers everywhere; tensions run high; angers flare; you've got to suffer with long lines everywhere you go and the streets become congested with increased traffic and pedestrians...

Perhaps you're going home to visit family, family which likely still has issues with your sexuality, no matter how long ago you came out to them. Perhaps you are bringing your lover, or going to visit his family.

It's all a far cry from a "Silent Night," generally.

The stories in this book are about men who somehow manage to find a moment's peace amid the Holiday madness, in finding the men who fulfill their desires. These are stories to entertain and arouse, stories you might imagine as you're lying in bed on Christmas Eve, staring at the frost on the windowpane and drifting off towards dreamland and fantasy, stories to read alone or to share with a lover the

power of words to excite the senses and the mind.

These tender, homoerotic glimpses of our longings for and frustrations with home, family, and each other, of the wonder of the Holidays and remembrances of youth, will leave you feeling a happy, warm glow.

Pink Santa Claus

Leigh W. Rutledge

A wave of bright red light broke over me, like the explosion of a bomb, and a drunk fell against me, shouting "Merry Christmas!" in my ear. He stumbled through the crowd, shouting "Merry Christmas" in the ears of other men—while sometimes reaching for their crotches—and then finally collapsed on the floor next to the video games. The music changed to a punk rock version of "Jingle Bells," a sleazy celebration of tradition. The dance floor filled quickly. Halfway through the song someone dropped a champagne glass, and all of the dancers, still dancing, moved as a group to one side: no one missed a beat.

A good-looking young blond hesitated near me. His face was congenial, his eyes rather vacant. "Hello there, gorgeous," he said slowly, swaying back and forth with a beer in one hand. "Pretty crowded tonight."

"It always is on Christmas Eve," I replied.

Two middle-aged men in full leather burst through the front door of the bar amidst laughter and waving and shouting to friends.

The blond turned to watch them for a moment, and then turned back to me. He looked expectant, like a little boy eyeing presents under the Christmas tree. "Can I buy you a drink?" he asked, his voice cheerfully promiscuous.

I smiled and shook my head, then finished my drink and set the empty glass on the bar. There was something much more interesting waiting for me at home. In fact, it was time to leave. "Have a nice holiday," I told him abruptly. I only briefly registered the look of disappointment on his face.

Outside, the city was wrapped in a heavy blanket of still-falling snow. The snow seemed to cast its own light as it fell through the air and paved the streets. Earlier the flakes had been almost as big as sycamore leaves, but they'd gotten smaller and smaller with

each passing hour as the air turned increasingly cold. My car wasn't far away, but I walked slowly, savoring the winter weather and enjoying the tense, child-like feelings of anticipation inside me. Pulling my leather jacket tighter around myself, I began to think about the different men I'd spent Christmas Eve with—the quick tricks and the slow fucks, the close friends and the lovers. Thinking of them gave me the warm satisfaction of remembered pleasure...

There'd been the Swedish violinist on his way to meet his wife and children in Las Vegas; he enjoyed licking beer off my ass and my balls, and he later wrote me a letter saying that he and his wife had decided to try a long-term three-way relationship with another man. There had been the skinny but beautiful vegetarian who enjoyed being tied up and spanked with a ping-pong paddle. There had been the Navy fighter pilot from Florida: we had sex in his Volkswagen down by the railroad tracks, and when it was over he gave me his flight jacket as an impulsive Christmas present because it looked "so fucking hot" on me. There had been John, my first lover—we spent four glorious Christmases together, until he decided to move to San Francisco in pursuit of a teenage bodybuilder who fascinated him. And of

course once, once upon a time, there was Vince...

I reached my car and brushed the snow off the windshield, and listened for a moment to the sound of distant Christmas carols being played somewhere in the night. The sky was orange-pink, and the buildings around me seemed closer, more intimately connected (as if the snow somehow telescoped distances) than they did in the daylight. I got in the car and headed for home.

I had met Vince at the bar on another snowy Christmas Eve several years earlier. When I'd first seen him, he was leaning against the cigarette machine. He had a dark, masculine face—not typically handsome, but still sexy, with a strong smile that flashed infrequently and illuminated his looks when it did. His blue shirt showed off his nipples and chest muscles through the fabric, and it was open several buttons at the throat. Around his neck, hanging down against the hair on his chest, was a thin silver chain with a small glittering Santa Claus at the end; from far away, it almost looked like dog tags.

There was something strange about him, a look in his eyes that instinctively discouraged me, as it seemed to have dissuaded almost everyone in the bar. Except for a few casual greetings, no one had

approached him the entire time he was there. I thought he would probably leave soon, out of boredom or thinking that the people at this bar were particularly stuck-up. Finally, though, I just went up and started talking to him. He was reasonably friendly, though a little distrustful. Initially, he maintained some distance. His answers to my questions were polite and amiable, but noncommittal and distracted. In fact, I wondered if he were cruising someone else. However, by eleven o'clock all that had changed: we were sitting together at a table, buying each other drinks and laughing heartily as he told me about his crazy childhood on Bleecker Street in New York. His full name was Vincent Christopher Martelli; he was thirty-four years old, and he told me he worked as a guidance counselor at one of the local community colleges.

By midnight, all the right things had been said and all the right moves had been made—we were in my car on our way back to my apartment. Vince's warm hand stroked my thigh, and he told me I reminded him of a kid he used to have sex with in high school. "I was afraid I was going to spend Christmas Eve alone," he added quietly.

At my apartment, everything started out fine, with

no hint of the trouble to come. We drank a couple of beers and then sprawled out on the carpet, in front of the Christmas tree. Vince pulled off his shirt, revealing a firm, beautifully developed torso with slightly hairy pecs. I leaned over and started sucking on one of his nipples, then let my tongue travel up to one of his armpits. He alternately massaged and gently slapped my ass, commenting on how small and boyish it was. I was vaguely disappointed, though, that his cock wasn't hard yet.

After several minutes of this, he suddenly grabbed me by the shoulders, with a restless explosion of energy, and pulled me on top of him, giving me a fierce, hungry, open-mouthed kiss, while jamming his hands down the back of my jeans. His fingers started to push apart the smooth cheeks of my ass.

Then, just as abruptly, he stopped.

For several moments, nothing happened.

"Vince?"

He didn't answer. He was staring up at the ceiling with a dark expression on his face.

"Vince?"

"Yeah?"

"What's wrong?"

"Nothing."

"Huh?"

"Never mind. Don't worry about it."

He got up off the floor and fumbled with a lamp on a side table. Click!—the sudden harsh light shattered the mood.

By habit, my eyes swept over his body. He had a brawny, handsome body, with that rugged maturity of flesh—an insinuation of depth and experience and authority—that can often make a man in his thirties or forties more heart-poundingly sexy than one in his late teens or twenties.

"I can't do it," he suddenly said.

"I don't understand."

"I can't do it," he said again. He grabbed his shirt from the floor and started to put it on.

"Sit down," I told him.

He shook his head. "I gotta go."

"Come on, sit down. Let's talk."

"No, not that," he said. "I don't want to be understood," he added sarcastically.

He started to button his shirt, but then stopped all at once and stood utterly motionless and undecided for a moment. Finally, he said, in a low, apologetic voice, "It isn't you, if that's what you're worried about. It just... takes a lot to turn me on. My tastes are

sort of... kinky."

"How kinky?"

"It doesn't matter," he said.

"Listen, I would really like to spend Christmas Eve with you, whatever it takes..."

"It doesn't matter," he repeated emphatically.

"No, come on, tell me. I can get into almost anything."

He looked at me doubtfully.

"Everyone says that," he finally replied softly. "But most of them run when they hear what I'm into." He hesitates and half-shrugged his shoulders. "I have weird... fantasies. Nothing that hurts anyone. Just... weird."

"How weird?"

He shook his head. There was a precipitous silence. "I... I sort of like... kids."

I didn't say anything.

"Not real kids," he added, as if concerned—and even slightly offended—by my lack of immediate reassurance. "I'm not into chicken. I neither would nor could do anything with a real kid. What I like is men who... act like kids, who act like boys. I like playing roles."

"That's okay," I said. "I once went home with a

guy who wanted to pin diapers on me and spank me while I pissed in them."

"Did you do it?"

I could feel myself blushing. I shrugged with forced nonchalance. "Sure. Why not?" I said.

There was a long pause.

"Relax, Vince," I finally told him. "Just tell me what you want."

He thought for a minute, with the look of someone battling a deep inner constraint. At any moment the words would come tumbling out of him impetuously: he was like someone standing on a high diving board, hoping their body would make the jump before their brain understand the consequences. "Well..." He hesitated. "There's one fantasy I've always had. I've never done it with anyone. You might not like it." He looked at me intensely, as if scanning my face for some sign of interest, of open-mindedness. "But you seem right for it somehow." His face was slightly flushed. "At least, it's appropriate..."

"Tell me."

"Sometimes, I've fantasized about..."

"Yes?"

"I've thought about pretending that I'm..."

"Yes?"

19

"Santa Claus," he announced in a harsh whisper.

At first, I only smiled and didn't reply. Then the smile broadened on my lips, spreading warmth into my cheeks. I tried to keep from laughing—but I just finally gave in to it.

"You think it's stupid," he said.

"No," I replied. "Not stupid. I mean... I don't know what I mean. It isn't frightening or disgusting or anything like that if that's what you're worried about. In fact, it's almost sort of, well, perfect."

His expression brightened a little.

"Tell me what to do," I said.

I tried to sound interested—more interested than I actually was. The fantasy didn't repel me; but I confess it didn't turn me on much. Still, I was willing to try.

"Well..." he thought for a moment. "You're the little boy who comes into the department store to sit on Santa's lap..."

I felt a renewal of laughter. I also felt a vague and unexpected stirring in my cock.

"...and we take it from there," he said.

"What do we need?" I asked. "I mean, do you want any props or anything?"

"Well... it might help if I had some of Santa's clothes," he said.

For the next twenty minutes, we went through every closet and dresser drawer in my apartment trying to find clothes for Vince's Santa Claus. I found an old pair of black pants and some snow boots; the pants were too tight and the boots were too big, but it didn't matter. I grabbed some towels for Santa's belly. The beard and mustache were a challenge we never did solve; this would be a dark, Italian Santa with the trace of a five o'clock shadow. The worst problem was the red jacket. I didn't have anything like that. Finally, after searching through the dusty corners at the back of the closet, I came across an old pink jacket I'd worn in high school as part of the school marching band. The huge gold buttons and epaulets made it fairly suitable to the fantasy; at least, it had a flashy look to it.

Vince's Santa slowly came together, quilted from bits and pieces of old and neglected clothing. When he was dressed, I took a good look at him in the light. He made an interesting, even sexy Santa: in fact, he somehow looked like every little boy's daddy dressed up as Santa on Christmas Eve. His eyes in particular were perfect for the role: they sparkled paternally, full of amusement and masculine warmth and wisdom.

"Now what?" I asked.

"Turn on the radio," he said. "Some Christmas music would help. All you need to wear is your briefs."

The first thing I found on the radio was some soprano singer wailing through Bach's "Vom Himmel Hoch." "God, no," Vince exclaimed. "Cheap music. Department store music." I finally located a station playing traditional, Mitch Miller-type renditions of middle-class carols. "Perfect," Vince declared.

Then I stripped down to my underwear. Santa's eyes glowed as he watched me peel off my jeans. He seemed fascinated by my legs and he suddenly commented, in a deep voice that was a little out of breath, "You don't have much body hair..."

"The whole family's a hairless bunch," I remarked with a shrug and a short laugh. "I guess it's genetic."

"Ahh..." he said, with a tremolo sigh. His eyes seemed to burn.

I turned off the lamp. The only light in the room now was from the Christmas tree, with its twinkling colors and the glints of reflection from the tinsel and ornaments.

Vince sat in a chair in the middle of the room.

And then, in the space between seconds, the room began to transform itself inside my mind. There were

suddenly crowds of people—harried last-minute hol-
iday shoppers with worn and frenzied but good-
natured expressions. People grabbing whatever they
could find on the shelves, no longer particular, no
longer concerned about matching the right gift with
the right person. There were the sounds of cash reg-
isters churning with sales, and bells ringing, and
people talking and laughing. There was the snow out-
side, and the reassuring warmth inside. There was the
sparkle and glitter of cheap, over-sized, department
store decoration—decorations that, although plastic
and commercial, still had some unaccountable power
to please and excite.

And in the middle of it all was Santa, shouting a
gusty, "Ho! Ho! Ho!" and patting his dark lap as he
beckoned to me to come closer. I walked towards
him and mentally tottered on the brink between
skepticism and blind faith. (Reduced to their basic
elements, what sexual fantasies aren't slightly absurd
and even potentially laughable?) But then I studied
him, and thought: He really does look a little like
Santa—pink perhaps, and lacking the usual thick,
white facial hair—but Santa nonetheless. The fantasy
started to enfold me.

I sat on his lap, and his warm arm slipped comfortably,

lovingly, around my naked waist. In that moment, my dick began to harden.

"Have you been a good little boy this year?" Santa asked me.

I smiled and nodded.

Santa smiled, too—a bit lecherously, I thought to myself.

"And have you been good to your mother and father?" he asked.

His fingers started to work themselves beneath the waistband of my briefs. At first he just gently rubbed my belly, reassuringly, right above the pubic hair; but then his hands moved slowly, furtively, down to my cock and balls. He fingered my dick and toyed with the head. Then he started stroking it as if it were a responsive lap cat.

"Yes," I said, a little short of breath. I felt an almost overwhelming rush of excitement, an unexpected mass of tingles and whirling anticipation in the pit of my stomach. This was the fantasy of being young again, of being a boy. Feelings of warm security seemed to percolate inside my brain—feelings of something wonderful and fresh, of something once lost and now regained—a feeling accentuated by my being in my briefs (with an unexpected hard-on)

and sitting on a man's lap with his own big erection pressing up beneath me.

I put my head against Santa's chest.

He cupped one hand around my erection and gently masturbated me, while starting to finger my ass with his other hand. His touch was sexual, but tender and caring.

Suddenly his lips came down on mine, and his tongue explored my mouth. He abruptly inserted the tip of a finger up into my asshole. I squirmed on his lap and whimpered. He smiled, and sighed with deep contentment.

"You can be as little and as young as you want with me," he whispered breathlessly in my ear.

And in the Christmas nog of lights and color and music, I let myself be sleighed away until morning, with Santa eventually ejaculating all over my thighs, and me experiencing the kind of luminous, helplessly spontaneous orgasm I hadn't had since I was thirteen years old...

~

I drove the car into the apartment building parking lot, skidding briefly on a patch of ice. The glassy flakes were coming down more heavily than before;

everywhere the details, the edges of the city were obscured and softened. The car heater felt satisfyingly warm, and I was tempted not to get out; but I finally shut off the engine.

There had been no new Christmas lovers since Vince. There had been no need for any.

I got out of the car and hiked up the steel stairs to the apartment, listening to my feet boom every step of the way, and saw that the main lights in our apartment were out. There was only the soft, unmistakable glow—slightly red—from the Christmas tree inside.

Quietly, I stood just outside the apartment door and (watching for nosy neighbors) removed my shoes, my socks, my shirt, and my pants. I folded them all neatly against the wall so the snow wouldn't get to them.

Then I went in...

The room was frantic with last-minute shoppers rushing in all directions and grabbing everything left on the department store shelves, while haggard and barely civil clerks tried to cope with the onslaught. Decorations flashed and flickered, almost blinding my eyes. There was the loud, comforting sound of Christmas carols. Even the air smelled of Christmas: of newly bought things, of spicy things, of things

that were warm and musky and full of the promise of pleasure and excitement.

"Ho! Ho! Ho!" shouted Santa from a corner of the room.

The magic was as potent and mysterious as it had been the first time—even if, in the back of my mind, I understood the perfect absurdity of our annual fantasy. Sure, it's something I wouldn't want most of my friends to know about. But as some obscure philosopher once observed, "Every person only understands his own love, and every other is foreign and incomprehensible to him."

My brain started to swim, and the big round head of my hard-on poked up ridiculously against the front of my underwear. For a moment I felt like an awkward little boy again—a boy who doesn't know what to do with himself or with the baffling erection coming out of his briefs. It was Christmas after all, and what child can contain himself?

I made my way towards Santa, and smiled at his admittedly atrocious pink coat. In the three years Vince and I had been together, there had been plenty of opportunities to buy him a proper red jacket—not to mention the appropriate white whiskers—but we never had.

A Cowboy Christmas

Lars Eighner

We don't get many callers here. You were in luck.
Cookie outdid himself on account of Christmas Eve.

Now, if you'll join me in the parlor for a little
brandy and a smoke, I'll show you to the bunkhouse
thereafter. The boy's gone to bathe in the kitchen. We
celebrate Christmas special, as you will know
presently.

I don't mean to inquire of your business, but if
you are at liberty, we could use another hand. You'd
be expected to make up your keep come springtime.

Well, I don't want to say so, but I noticed you were
particularly attentive to Cookie's offerings. You sleep

on it. But if you are considering the job, there is a story you ought to hear.

You understand, I speak for the boy as well. What I say goes.

Let me draw aside the drapes. This is the biggest window on the western trail. It was carted out all in a piece from St. Louis. See that pass, you can just make it out in the moonlight. Through that pass, the notch south of the big peaks, lies the high range.

This brandy is supposed to be good, but I wasn't born to brandy. You can see that. No, the old man left a quantity of this when he passed on. He favored it a great deal in his last years.

Seven years ago last October, we were a crew of five or six on the high range; the boy and me and the strawboss, Will, and a couple of the others. You're a sheep man, aren't you? Well, we run some sheep up there after the cattle come down. Not like the old days in Texas.

We had seen a flake or two of snow, but nothing to amount to anything. Still and all, time was getting by. Damned if the boy didn't break a leg.

The rest of us, all pulling together as hard as we could, managed to splint it straight. He tried his best not to show it, but I reckon we hurt him pretty bad.

We sent the others down with the stock. Will fashioned a pretty fair sled from the remains of an old wagon that must have broken down when they built the cabin up there. We waited for the boy to feel more himself until we could wait no more. One evening, at dusk, the snow began to fall in earnest. We knew it meant to close the pass. But the boy didn't want to move.

He had a pistol that we had left him sometime when all of us had left him alone in the cabin, so there wasn't any arguing with him. Will and I drew straws and determined that I'd stay.

Of course, I was just as happy not to be the one to have to tell the old man that his boy was going to winter it on the high range.

We had beans and flour enough, so Will left me the rifle. But the boy suspected a trick. He lay awake all night with that pistol, and most of the next day. But by that time any fool could see that the two of us were snowbound.

Have some more of the brandy.

The boy was up and about by Thanksgiving. He felt foolish about keeping us up there, but done is done. His traps kept more than a little meat on the table, which was just as well, because I don't do

much harm with a rifle at any range to speak of. In fact, we resolved to lay some by for Christmas, and I made a little lean-to which served as a smokehouse.

Once he was on his feet, the boy was frisky and full of beans. He thought he'd fix up the cabin to stay the year round. The old man had been in his cups since the boy's mother died. He beat the boy pretty regularly and wasn't too nice to the rest of us, either. I can't blame the boy for wanting a place of his own.

One more brandy and I'll take you up to the bunkhouse. Be generous with yourself. You'll find it nippy when we step out.

You see, the boy's filled out to be quite a man. You should have seen him that winter. He has put some meat on his bones since then, but he was a fine young buck then.

Yes, you know what I mean.

As December went by, the game got scarce. I could not pretend to be hunting. We didn't go far from the cabin. The storms come up quickly. I began to get somewhat restless.

The boy, well, he's religious about his bath. When his snow was melted in the evenings, he'd have his bath and stretch out naked in front of the fire to dry. You know, the wind would be whipping the loose

snow around outside. I'd be sitting there. And his lit-
tle rump would be all red in the glow of the firelight,
with those golden furry hairs just a glitter.

You know how long the nights get up there.

By and by, it was getting to be Christmas. He kept
saying that Kris Kringle had lost track of him. He only
meant it didn't seem much like Christmas. All the
time, the thought of that tight little butt was preying
on my mind.

I'd go out behind the lean-to for some relief. But
it couldn't freeze enough to cool me off.

I was losing sleep. My temper got short.

Still, we wanted to make the best of Christmas. He
melted down snow and made a regular laundry so we
each could have a change for Christmas Eve. While he
went to check the traps, which was pretty useless by
then, I decided to have a bath—I don't suppose it's all
that healthy to bathe like that in winter, but he had
shamed me into it. I spread out the table with the
meat and tortillas and a bit of whiskey left from
splinting his leg. When he got back and saw me in the
clean duds and the whiskey on the table, he bright-
ened a bit and admitted he had some applejack
stowed away.

Dinner went well enough. We warmed to the

liquor. But I have spent merrier Christmases. He cleared away the table. Then he began to make his bath, just like the other nights. I pretended to clean the rifle, like I did every night, to keep my hands busy.

Pour yourself another and put on your boots. I'll show you to the bunkhouse.

He'd always had those big round shoulders and flat belly. He didn't wear the beard then. He didn't seem to notice or mind my watching him. He's squeeze out the sponge, and the water would run down his back, right into the crack of his ass. When he bent over to wash his legs, it hurt in my pants.

With the liquor in me, I just leaned back and almost shut my eyes, watching the flicker of the fire as he scooted his belly onto the sheepskin and turned his head to the fire.

"Joe," he says when I thought sure he was asleep, "why don't you show me how?" He wiggled his ass, which looked all the whiter on the black sheepskin. "I seen you one Saturday night with Will. I watched you through the loop of the bunkhouse door."

I knew he was telling the truth. I remembered the night he meant. The others had gone off. Will and I

had got going before we thought to blow out the lamp.

"Do to me what you done with Will," he says.

A man is only flesh and blood. I figured the old man would kill me if he got wind of it. But I thought I'd have a feel of it. Ain't no harm in that. If they start shooting cowboys for patting each other's rumps, they'll run out of rounds in a hurry.

I squatted next to the boy. I swear, I really thought I'd just have a feel of it. I laid a hand on his flank. Those cheeks flared up and pressed firm against my palm.

I began to suspect that I would have to have some.

"It'll be good," he says, all the time churning his belly against the sheepskin. "I've practiced all I can by myself. I'll be as good as Will."

"I know," I says.

I stood up. In the back of my mind I was thinking that I ought to reconsider. But while I was reconsidering, I was letting down my jeans.

As soon as he saw mine, he got his hands on it. He sat up and stroked it a bit, as you might stroke a cat.

I reckon he wanted it real bad. All he knew about was from watching me and Will that once and however he had contrived to practice by himself. The

instant he touched mine, his cock stood straight up.

I hadn't seen it hard except for glimpses when he rolled about on the sheepskin in his sleep. He had a man's cock then, as he does today. I took it in my hand. It was hard as a saddlehorn, bouncing against his belly. I gave it a couple of healthy strokes. He got the idea and gave mine a good squeeze back. He was already gasping like a trout out of water. I thought that might be the end of it right there.

But he stopped and looked me dead in the eye like he was going to say something. Instead, he flopped on his bunk, beckoning me with his fanny.

"Please give it to me, Joe."

I lowered myself down over him, thinking I'd just rub up the crack of his butt a bit.

I was still thinking he would never take it in. Then I looked at the red head of my prick, plowing up the valley. It just made me wild.

I spat on my cock, saying to myself the whole time, "Cowboy, this piece will be the death of you." I figured I'd go in hard and fast, and then I'd lay there until he settled down from the pain. But when I pressed firm against his tight little knot, it swallowed me up.

He just took it in.

Then he clamped down.

I've held onto reins for my life, but I've never grabbed nothing like his butt grabbed me. I stopped dead. I could have lost my load that second.

After a moment, I gave him one of those long, low strokes, everything I had, just to see how much he wanted. He squirmed, but just whispered, "Please, Joe." And that weren't a complaint.

When I pulled back, his whole body came halfway with me, like he thought I wasn't about to put it right back.

The fire was low. The room was chilly. I hadn't given him three strokes. I looked to see my cock half in him. I was dripping sweat. A pretty picture, those cheeks tense and all aquiver, rearing back and trying to pull the rest of my cock back in.

Presently he was up on his elbows and knees, pressing his spine against my belly, milking my cock. I reached under him. It was harder than before. The head of it was already as slick as a sheepshearer's hands. When I got my fingers around it, he dropped his first load. "Don't stop on account of me," he says.

And I didn't.

I twisted him over on my prick like beef on a spit, kissed him soundly, and kept on pumping.

I thought of those nights he'd lain out bare-assed. I thought of the times I'd watched him fall asleep, waiting to hear him snore so I could get some relief in the corner, I thought of my cock rubbing itself red inside my jeans, aching for that tail, never thinking it would get there.

The more I thought, the harder I fucked him, looking him square in the eye, thinking of how I had hurt to get where I was. And he was looking back that look, daring me to fuck him as hard as I could, teasing me because he knew I couldn't make him hurt. "Say it's good, Joe."

"Damn right," through my teeth, I says, "damn right it's good."

He pushed my chest back with his legs, so as he could get his hands on his cock. I reckon it never did get soft. I got another eyeful of his butt taking my cock, so I slipped it all the way in and out. He whimpered when I pulled it out. "Give it back, Joe, now."

His cock jumped again, with those big nuts hugging it tight. His gut twisted over my cock. I could see the ripple in his gut. His first wad whipped over his head, thick and white. He ripped my load out of me. I spent inside him until it was flowing back all over us.

I'd never spent like that before. But I wanted to keep on fucking him. He begged me to keep it in. I did.

I don't know if I fucked him all night. I just remember that when the gray light came, he was sitting up on top, riding on it.

I never thought I could get it on my back, but he proved me wrong. He didn't seem to be done, so I put him in me. That didn't last as long as it takes to tell of it. He's learned a lot since then. "Looks like Kris Kringle brought me something after all," he said. That day to this, that's how it's been—partners.

When the thaw came, we got down. The old man had a fit of apoplexy while we were gone. I don't say it was just as well. I just say sometimes things work out for the best. We made short work of mourning him.

Will, I think, had it in his mind to run the place once the old man was gone. Will's a gentleman, though. When he saw how the boy looked at me, he asked for his references right then. He's doing well now, I hear.

I can see you didn't mind my tale. I've got to get back to the boy now. There's the bunkhouse.

All the hands here know the story. We don't keep

none that think ill of it. I reckon if you keep your eyes open around the bunkhouse, old Kris Kringle will find something for you, too.

Now, good night, sir. And a very merry Christmas.

Under the Tree

M. Christian

Roy awoke on Christmas morning, alone in their big bed. Wandering downstairs, he found the tree lit up like a constellation of glitter and lights. Under the tree were four small boxes. Each was wrapped in red foil, tied with a brilliant length of ribbon, and topped by a large, floppy bow. Aside from their sizes, each one looked perfectly identical.

There was no sign of Joshua.

Each present had a small, if gaudy, gold tag printed with a turn-of-the-century Saint Nick hefting an overflowing bag of gifts. Picking one of the boxes at random, Roy flipped the card open: *Two*, it read,

printed in Joshua's precise architect's handwriting. The box was surprisingly heavy and when Roy shook it, the insides shifted sluggishly back and forth.

Three was the largest of them all, and clearly the heaviest. It could have held a pair of strong work boots for its weight and size but Roy doubted his own private Saint Nick had given him those for Christmas.

One was very light, about the size of a box of tissues, though much heavier.

The last, Four, was the lightest of them all: it felt almost empty, as if a jolly Spirit of Christmas had given him a memory or a bit of laughter. Somehow, Roy doubted that Joshua would have given or been given something so intangible. Four was about the size of a deck of playing cards through not as nearly as heavy. When Roy shook it, something light flopped around inside.

There was still no sign of Joshua.

When Roy had taken up the offer to spend Christmas through to New Year's at Joshua's upstate cabin, he'd suspected something like this would happen. Surprises were Joshua's art and passion. In many ways, Roy found the thin young man's passion obsessive, at best, and highly annoying when he was not in

a charitable mood. But Joshua approached surprises, presents, and celebrations with such verve, flair, and abundance of enthusiasm that—while it might tip the scales toward fanatical—the joy it obviously brought him and those around him more than compensated for his zealousness.

Despite his mental preparedness, Roy was still a little upset by Joshua's vanishing act. It was unusual—Joshua always made a point of being present at each of his surprises—to laugh, cry, and applaud right along with the recipients. For him to be missing was ... odd.

Roy looked in the kitchen—no sign. The coffee maker was perking merrily away, turning water into caffeine, and a still-warm plate of danish was out on the white-tiled counter.

Roy recalled one birthday surprise Joshua had planned for Lars, his lover at the time. It was something Roy had only heard about second-hand, but the story had been told so many times that it had grown into a kind of legend. Lars had just turned a dignified/refined fifty—a gentle slide into gray hair and an overly correct posture—something, it seemed, Joshua found more than a little premature and too stiff for his usually playful lover. So, when Lars

43

walked into the blasting applause of his surprise birthday party he found just about every good friend he had ever had ... and a huge rectangular cake with exactly fifty candles burning merrily away. It was only after all the shouts of "congratulations," "many more," and "love you, man" had died away that everyone realized that the person who had arranged the bash was missing... that is, until someone noticed that one of the candles on the cake wasn't lit and was suspiciously shaped like Joshua's hard cock, sticking out of the sweet icing. Joshua, laughing, burst from the cake—naked, hard, and smiling—and gave his lover a big sweet hug and a kiss.

Lars had been surprised, and more than a little suspicious about why that certain party guest—a good, personal, friend of Lars'—had been so sure that the hard cock on the cake had been Joshua's. In addition to being imaginative and playful, one thing that characterized Joshua was never, ever being able to say "no" to anything.

Joshua wasn't in the den. A small fire flicked playfully in the fireplace and Roy noticed that the chess set had been set up for another late night game. After sex (especially after sex) it was Joshua and Roy's favorite way to spend an evening.

The workroom was empty and cold. The computer, which was on more often than off, sat dark and silent. While Roy liked to work pretty much every day, it had been their semi-mutual decision—Joshua had pouted only a little—that Roy's next issue of HardLove could wait until the day after Christmas. Even editors need to have some time to relax, Roy had argued—especially on Christmas day.

Roy climbed the cabin's short flight of stairs up to the second floor and the guest bedroom. In many ways, Roy considered his temperament to be closer to Lars' level demeanor than Joshua's playful friskiness—and normally, he sought out the same traits in others. But he'd found himself fascinated by Joshua, long before he met the man. The stories he'd heard: One time, for a gallery opening, another surprise for another lover, the statue had turned out to be none other than Joshua, shaved and painted a thick coat of white. Or that time Joshua had picked up his screenwriter boyfriend after the Academy Awards, passing by hundreds of paparazzi, crowds of thousands, the rich and the famous and the powerful—it was only as his lover got in the passenger seat that he noticed (hopefully with a smile) that Joshua hadn't been wearing pants. He'd worn a dress coat, and his cock

was done up with a bow tie—but no pants.

An envelope was taped on the guest bedroom's door.

When he finally met Joshua, it wasn't love he felt so much as respect. Some people looked at Joshua like a piece of embarrassing fluff, someone who was all but guaranteed to say the wrong thing, wear the wrong colors, flirt with the wrong person, and then cap the evening off with one of his notorious pranks. But, quickly, as Roy'd met Joshua more and more often, soon becoming a regular friend and lover, Roy realized that the Joshua these people thought they saw wasn't the one that was really there.

Another turn-of-the-century Santa, smiling his chubby smile and puffing on his now politically incorrect pipe. Joshua's immaculate handwriting: Merry Christmas, lover! Go downstairs and open your presents, in order, then bring them back up—I think you'll know what to do.

Yes, Joshua was a merry little sprite—a mischievous little queen who could camp it up like the rest of the girls. But there was something more under his affected, sometimes grating lisp. The little blond architect didn't always say the wrong things, flirt with straight friends, or tease bosses and the power-

ful. It took quite a sharp little mind to so perfectly plan and execute his pranks. He might hide behind the image of a blond twink, but Roy saw through to the mind and man beneath—and found himself in love with the real Joshua.

Downstairs, Roy picked up One. It was immaculately sealed and therefore took a (smiling) full minute to open. A blindfold. It was soft black silk, with a thin Velcro strap. Running his hand over the material, Roy smiled again, remembering the time they'd fucked in the dark—flowing over and into each other, guided by the feel and touch of their bodies. "Who'd have ever thought that getting rid of your eyes could be so much fun?" Roy had said. Joshua, it seemed, had been listening.

Two was a pair of black, anodized, Smith & Wesson double-lock handcuffs. They were beautiful. Playfully, Roy clicked and unclicked them, hypnotized by their action, their matte perfection.

He should have anticipated Three, after Two, but it took him by surprise. Roy smiled yet again, thinking how Joshua must have had a real bitch of a time finding a matching pair of leg cuffs. But somehow he had done it—Roy was holding a pair of "giant's" cuffs. Ratcheted down to their smallest size, they wouldn't

fit on anyone save a pair of industrial-sized wrists, but would perfectly fit around an Average Joe's ankles. The chain between the also-matte black cuffs was longer by three or four times, so "prisoners," or lovers, could still walk.

A short, wide strip of smooth leather fitted with a small rubber ring and a series of snaps was in Four.

They were all perfect.

Roy liked sex. A lot. He knew a lot of folks who had other things that came first—their careers, family, even (for some reason) sports. Roy could care less about his job; he liked editing HardLove, a lot, but it wasn't all there was to him. His family was important, but he knew where he ended and they started and kept those boundaries in place. But sex—now that was what Roy really liked.

Luckily, so did Joshua. And, spectacularly, that special click was there between them, that perfect matching—a link of perfect symmetry between them, regardless of who was fucking and who was fucked, who was sucking and who was sucked. Roy didn't find that connection often, but he and Joshua found it whenever they rolled around on their respective king sized beds (or in one of their kitchens, in one of their living rooms, in front of a

fire, in the snow, in some alleys, and even in a cab or two).

With that connection was a kind of playful experimentation—still with that unspoken joy. They had tried almost every kind of toy and tool available in stores or by mail-order and had put together a sizable, and very well enjoyed, toybox. Cock rings, especially the kind that was in Joshua's Christmas present to Roy, was one of their all-time favorites.

Four also held a card, a match to the one on the bedroom door: Bring your four unwrapped presents upstairs; it's time to wrap your fifth.

∾

The room was warm and lovely. A small wood stove in the corner burned crackling logs, and an antique oil lamp threw gentle shadows on the rough-hewn log walls. This was one of Roy's favorite rooms in the cabin: with its antique chest of drawers and prints of ducks on one wall and gentle snow scenes on the other.

Spread-eagled on the bed, naked and glowing almost as much as the fire, lay Joshua. His cock, proud and glistening from what smelled like baby

oil, stood achingly straight up from his shaved balls.

"Wrap me up, Sir," Joshua said in a playful voice, a sweet and subservient voice.

Roy smiled, putting down his armload of presents on the bed, and kissed him: brandy and peppermint. "You're the best gift of all," Roy said, kissing his lover's high forehead and rubbing his hand along Joshua's smooth and equally hairless chest.

Roy picked up the handcuffs and carefully ratcheted them onto Joshua's thin, pale wrists. He took the point on the other end of the keys and locked them so they wouldn't tighten further.

"That feels good," Joshua said, squirming like a playful puppy.

"We're just starting," Roy said, kissing a sweet line down Joshua's chest. He wrapped a hand around Joshua's hard cock.

The leg cuffs went on next, exactly same way: black anodized metal clicking smoothly around Joshua's smooth ankles, then locked into place. "Comfy?"

"Deliriously," Joshua said, shifting his body right to left, making the chain between the leg cuffs chime.

"Lights out now." The blindfold wrapped easily

around Joshua's head, his eyes vanishing beneath the soft silk. His mouth smiled, wide and inviting.

"Candy cane?" Joshua begged, opening his mouth even wider. He stuck his tongue out and flicked it playfully back and forth.

Roy laughed and tussled Joshua's blond hair, then stepped away from the bed and stripped down. Naked and glowing in the warm firelight, he walked up to the bedside.

Joshua couldn't see but somehow he knew—lover's radar?—that Roy was standing there, right next to him. He rolled over (chains chiming again) and gently licked the underside of Roy's hard cock. A small bead of silver pre-cum started to form at the tip. As Joshua continued to lick, the bead slowly started to drip down the underside of Roy's cock. Joshua expertly flicked his tongue and caught it. After savoring its texture and taste, Joshua pushed himself higher, bracing on one arm, and slowly eased his mouth over Roy's cock. At first, he held only the head between his lips. Slowly, almost ponderously, he began to ease the entire length of Roy's swollen cock into his mouth.

Roy could never quite figure out exactly what tricks Joshua knew, what magical surprises he could

perform with his tongue, lips, teeth and throat—like Joshua's apparent lack of a gag reflex. Roy suspected these were the same tricks and surprises Joshua did for all the people he cared about. With Joshua mewing like a contented kitten as he sucked and worked his cock, Roy was happy and grateful to be one of those people the little blond architect cared about.

When his legs started to quiver and quake and he felt he was about to come, Roy pulled out, leaving a gentle thread of pre-cum (because he hadn't, not yet) trailing from Joshua's mouth to his cock.

"Lie back," he told Joshua, reaching down for the ring, "time to wrap the final present."

With expert care, Roy snapped the cock ring across the top of Joshua's cock and around his pristinely-shaved balls. Making sure no skin was pinched (though Joshua would, of course, have told him if there was), Roy looped the crown through the rubber ring, until it was snug if not tight. He gave Joshua's cock a few playful strokes until it was hard again, almost painfully so: the restrictive bands around his balls and the shaft of his cock made the veins stand out like they were vines climbing a marble statue. Pre-cum drooled down from the tip.

"Never a better present," whispered Roy, stroking

Joshua's cock, a smile on his face even though his lover couldn't see it.

Roy licked and then began sucking Joshua's cock—tasting the salty bitterness of cum on his strongly working tongue. For what seemed like hours, Roy knelt beside the bed, his elbows on the mattress, and bobbed his head up and down, up and down, on Joshua's beautiful cock. At the head of the bed, his lover made soft mewing sounds spiced with the occasional bass grunt that mean he was coming closer and closer to coming.

"Please," Joshua begged softly, almost too softly to be heard above the crackling fire and the wet sounds of Roy working on his cock. But Roy did, indeed, hear him—and slowly eased his mouth off Joshua's throbbing, jerking cock.

"For you, anytime," Roy said, getting up onto the bed, up onto Joshua.

For a while he just knelt there, legs on either side of Joshua's body, their slick cocks rubbing against each other as Roy bent down and kissed his lover. They kissed—tongues dancing together as they hissed and moaned into each other's mouths, both tasting each other's saliva, sweat, and bitter/salty cum.

It was hard for both of them to say how long they stayed that way, their cocks rubbing, their tongues working, but they both knew it was a long time—a deliciously long time.

When it felt right, Roy reached down and grabbed Joshua's cock. He leaned over his lover for a box of condoms and lube in a basket under the antique chest of drawers. "And now, the final wrapping," Roy said, unrolling the latex over his lover's cock.

He leaned down and kissed his lover again, their tongues again dancing together between their mouths as Roy eased himself open with a lubed finger. He lifted Joshua's cock, held it between his legs so that it rubbed against his asshole. He shifted back and forth, rubbing the cock against him. With his right hand, he opened himself further, two fingers, then three, then slipped Joshua's cock inside.

This moment was special, intimate, timeless like their kisses, but it wasn't simple or subtle: they fucked like lovers, that kind of sex that wasn't the burning fuck of a first time between two people or the too-common fuck of people too bored with each other. This was a special time between the two of them, a special fuck with all the intensity and passion of new lovers, and the intimacy and comfort lovers

who knew each other's bodies. Roy rocked gently, back and forth with a kind of hobby-horse rhythm, listening to the sounds they made as Joshua's cock slid in and out of his asshole, listening to the jingling of the chains, the creaking of the bedsprings, and the moans that escaped their lips and throats.

They were lost for a time, somewhere between the hardness of their cocks, the source of their desire, and the overwhelming release of orgasm—which seemed to be somewhere close, but not too close.

Then the fever started, the quick trip from lovers fucking to lovers coming—and soon the speed and vigor of Roy's ride increased. He grabbed his own cock and started to fist himself in a counter-point to his being fucked. Joshua's groans climbed the sexual music scale from turned on to starting to come.

Which he did, in jerking, quaking spasms. Roy felt Joshua's cock swell within his ass as it released into the condom's reservoir tip—then he lost track of that feeling as his own cock exploded across Joshua's chest. Their orgasm seemed to last as long as their fucking and kissing: timeless and undefinable. When it finally ended, when they were too exhausted to do anything but sleep, Roy managed to climb off his lover, undo the cuffs (both sets) and remove the

blindfold. Then he crawled next to Joshua, kissed him on the cheek and started to fall asleep.

Just before he lost consciousness, though, Joshua kissed him and said, "Merry Christmas. I hope you liked your presents."

Roy just smiled and kissed him back.

Season's Greetings

Lawrence Schimel

It had been a long time since I could remember snow in November, but it was hardly unheard of for New York City. The weather had been so wonky the past few years, with global warming and El Niño and whatever new causes or theories they were blaming now, that I wasn't really surprised by anything that fell from the sky any more, no matter the season.

I was surprised, however, as I checked my mailbox while waiting for the elevator, to discover I'd gotten my first Christmas card of the year. I know that traditionally the Christmas sales season starts the day after Thanksgiving and all that, but this was way too early

for a card. I briefly contemplated waiting a few weeks before opening it, when Christmas felt like it was in high gear, but I've never been good about delayed gratification; even when I was younger, I'd sneak into the living room when no one was looking and pick up my presents under the tree and shake them to try to determine what was inside, even though I knew I'd be in big trouble if I opened them before Christmas day itself. I could, however, wait until I'd gotten upstairs and had warmed up a bit, before opening the card; after all, I knew from the postmark that it was from John.

I stomped my waterproof boots on the mat outside my apartment door, and took them off so I didn't track snow inside. I took off my hat and gloves and scarf and jacket and one of the sweaters I was wearing, and put a pot of water on to boil for tea. I looked at the AIDS benefit calendar hanging on the fridge, with black and white photos of naked men by Jeff Palmer, and confirmed that it was indeed still the 29th of November—far too early to be getting Christmas cards.

I took the pile of mail and sat down on the cushioned window seat I'd built over the radiator and hence suffused with a delicious warmth. There was a

catalog from J. Crew, a bill from AT&T, and two different envelopes filled with coupons from local establishments. I opened both of the latter and rifled through the traditional storage and car service adverts, looking for the coupon for my local grocery store and anything new that caught my eye.

Then I opened John's Christmas card. It depicted a foil-embossed wreath and had a preprinted greeting inside that read: WITH ALL THE WARMEST WISHES FOR JOY THIS HOLIDAY SEASON. John had printed my name and signed his own above and below the store-bought sentiment. That was it.

I didn't quite understand why people bothered to send cards that said so little. Two bucks for the card, thirty seven cents for the stamp... to say absolutely nothing, except maybe "remember I'm alive." Passive-aggressive blah blah blah.

John was a guy I'd tricked with three years ago in Montana on a business trip held in one of those convention centers so far off the beaten path the rates were dirt cheap, so all sorts of miserly industries liked to hold their trade shows there. John was the stereotypical blond farmboy type, big and beefy and dumb as a post. The sex had been delicious in that purely physical way sex can be, when two bodies are equally

aroused by each other and fit together as if by magic. He had one of those cocks that bent kind of funny even when it was hard, and I was sure it would be awkward to find a comfortable position for him to fuck me as a result; but maybe I know less about the insides of my rectum than I thought, since no matter what we tried (and we tried many variations that night) felt great.

John was tender and sweet and affectionate, even if we had absolutely nothing in common to talk about when we were not fucking. I'd given him my address in New York so he could look me up if he ever came for a visit, more than willing to spend another night of blissed out pleasure with him if the opportunity arose. I couldn't fathom spending time with him with any regularity. And I hardly wanted to maintain a long-distance affair with him—they're taxing and difficult in the best of circumstances. But I'd be happy to see him again for a fuck.

I tossed John's card onto the pile of junkmail and wondered if he'd ever come to New York. He obviously still remembered me enough to send me a Christmas greeting, empty though that greeting had been. I thought about his cock and the way it had felt in my mouth as I held it there, waiting for it to get

hard for a third time that night...

I unbuttoned my jeans and pulled out my dick, thinking about John and the sex we'd had. It didn't take long for me to have a full erection. I remembered again the funny bend in John's dick as I stroked my own, and tried for a moment to twist my cock into that same bent shape. It didn't quite work, and I quickly gave up and settled in to my usual masturbation stroke, pulling long and hard along the shaft and stopping sometimes near the glans to rub the sensitive skin on the underside just below the crown.

I glanced out the window at the thick white flakes of snow falling from the sky and noticed that my neighbor across the street was watching me jerk off. And not simply watching, he had his dick out as well and was jerking off in time to my own motions.

It's a bit of a shock to suddenly discover you are having sex with someone else, when you didn't realize you weren't alone. And even though we weren't having what would traditionally be called sex, that's what it felt like nonetheless, sex with each other even from our separate apartments across an alleyway slowly filling with snow.

I wasn't sure what to do, so I didn't do anything. That is, I kept jerking off, and he kept jerking off, and

we watched each other. He had a nice body, from what I could see of it through the storm and the distance. He was completely naked, whereas I was still clothed with just my crotch exposed. I paused in my jerking off to take off my other sweater and unbutton my shirt, leaving it on my shoulders but open.

My neighbor was very different from John's beefy bulk, which I had just been fantasizing about. My neighbor was sleekly muscled, with nice definition on his abs and especially his obliques. He was that olive complexion that could be from any of various Mediterranean or Middle Eastern cultures, and had dark hair and dark eyes and a mat of black hair across his chest but not all the way down his stomach.

I tried to think if I would stop to cruise him if we met on the street, or if this were one of those types of encounters like in a bath house, when you're horny, and you engage in sex with the most attractive of what's available and often have a perfectly enjoyable time even though you might not, ordinarily, have thought to pick up that given man, had you run into him on the street with all his clothes on. Sometimes, in a steam room, attributes which are not obvious in the "polite" world of social gestures and clothes prove to be quite enticing when encountered

by the hand, the eye distracted by clouds of vapor or dim light.

I couldn't decide. I was a little nonplussed by the suddenness of it, my being unaware of his being sexual with me before I had had a chance to decide if I wanted to be mutually sexual with him, but it was more surprise than any sense of violation or distaste. Of course, that may simply have been because I thought he passed some ill-defined mark of handsomeness, or because I was horny from my fantasies about John and from not having had sex or jerking off in a few days.

I watched the way his arm flexed as he tugged on his dick, which curved gently upward in the classic erection. My own dick was more direct, sticking straight out from my crotch at a perpendicular angle. I shifted so I was kneeling on the window seat, and pressed my dick up against the window pane so it stood upright, so my new friend could see it better. The glass was cold, making me clench my balls involuntarily and flexing the muscle at the base of my dick, thrusting it harder against the glass.

The whistle on the tea kettle went off, but I ignored it. There were five cups of water in it; it would be a while before it boiled itself dry.

A bead of pre-cum ooozed out of my dick, white like a little puddle of melting snow. I pumped my ass muscles, rubbing my dick against the glass and making a little trail across the pane as my neighbor's arm moved faster in its motion. I wondered if anyone else was watching, and what they would think, but I didn't really care, caught up in the moment of our sex. I sat back onto my heels, still facing my neighbor across the alley, and took my dick up in my hand again. His hand and cock were a blur as he jerked off with the intent to come, and I too began to move my arm faster, squeezing with my fingers as my hand slid along the shaft and cupping my balls with my other hand, to help with the race to the finish. I felt, for a moment, like a teenager in one of those infamous circle-jerks I had never had the luck to take part in when I was actually that young. Of course, I was born too late to play games like "sticky biscuit" where everyone ejaculated onto a cracker and whoever shot last had to eat the soggy mess. I smiled wryly to myself at the ironic thought that this was almost a metaphor for what safer sex had come to, during the epidemic: two men jerking off with each other from across an alleyway. But actually, I felt we had more intimacy, despite the physical separation, than some of the men

I'd tricked with here in the Big Apple.

My neighbor leaned forward suddenly, his breath fogging the glass in front of his face so I could no longer see his features clearly. And then suddenly there was a second smaller shadow lower down, a series of white splotches that together made a sort of Rorschach blot image of a dove before they began to drip toward the floor.

He waited for me even after he'd come, a gesture I found touching, especially considering the anonymity and distance inherent in our encounter. He lingered in his window, running one hand through the splotches of his cum as if he were using his semen to make a finger painting for me—or caressing my body from afar, using the window as a substitute for my skin, a metonymy of sorts. I squeezed my balls tight with one hand, clenching that muscle that makes them pull up higher against my body, and pumped my hand faster, wanting to come for my neighbor. And after a short while I did, my hips bucking forward as I ejaculated, although I kept my back arched so that I sprayed lines of semen across my own chest instead of the window pane or the fabric of the cushions.

He smiled as I came, his whole face lighting up,

and once I had caught my breath, I smiled back at him. Then he disappeared from his window—presumably to clean up. I ran my fingers through the viscous clumps of cum that clung to the clipped hairs of my abdomen and slid down toward my crotch, thinking I should do the same. I stood, cupping one hand to catch the runnel of semen so it didn't fall to the floor, using my other to hold my shirt away from my sticky chest as I went into the kitchen. I turned off the stove, then wiped myself off with a paper towel, rearranging my clothes as I finished.

Mug of Red Zinger tea in hand, I started walking back to the living room. Through the doorway, my warm, comfy window seat beckoned, and I thought about my newfound neighbor. "How very interesting," I said aloud before pausing and lifting the mug to my lips. I smiled and, still standing in the doorway between rooms looking out toward the window beyond, took a sip of tea.

～

I didn't see my neighbor again for days.

At first, I was constantly aware of his possible presence any time I was in the living room, that he

might, at that moment, be glancing across from his apartment—or perhaps he was even actively waiting to catch a glimpse of me, as I sometimes did, idly passing in front of the window as if to check the weather and looking out toward his apartment. I thought of him especially whenever I sat in my window seat, as I did often in those cold days that grew shorter and nights that grew longer. But if he sometimes saw me, I didn't ever catch sight of him, our schedules off-sync except for that one brief moment of, yes, sex, the intimacy we had shared across the gulf—both the physical chasm between our buildings and the emotional anonymity that cloaks New York City—that separated us.

I was intrigued by him, and not simply because he was sexy and relatively convenient. It was so uncommon for someone to acknowledge the voyeurism we all practiced. New York being an island, we build upward since we can't expand out to the sides. Buildings are crammed up against each other, and, naturally, we can see into the apartments of our neighbors sometimes, but it is one of the unspoken rules of New York that you never acknowledge this— otherwise, how could you live in comfort, constantly aware of your neighbors' surveillance? As I had

been, since our encounter—although in this case, I was not perturbed by it, and was in fact eager for it to happen again.

The unusual snowfall melted by the beginning of December, and walking home through the streets crowded with Christmas shoppers, I would sometimes pass a handsome man who looked back over his shoulder at me, and we would both stop and turn around on the pretense of window shopping and start talking. I always tried to arrange for us to go back to the other man's apartment for sex, feeling somewhat self-conscious because of my neighbor, certain that even though I didn't ever see him, he must be as obsessed with my private life as I was with the idea of his. I thought my neighbor might be jealous to see me with another man, and then I realized that his jealousy might be a way of my luring him to the window again.

The next man I met who made my dick leap to attention at the thought of what we might do together I invited back to my apartment and undressed him in the living room, sucking his dick from the window seat. But I was too distracted to enjoy his body, thinking about my neighbor across the alley who did not appear, and soon I moved us into the bedroom so

I could focus on the quite-enjoyable sex with the man at hand and not the idea of possible sex with the one I was obsessed with.

The next time I saw my mysterious neighbor was on December 11th. I didn't get home until late because of the office Christmas party. I was sitting in the window seat reading the day's mail, as was my habit, when I realized I had a Christmas card from someone whose surname and address I didn't recognize. It was here in the city, and was addressed to me, but I had no idea who it was from. The card was a winterscape image of ice skaters with SEASON'S GREET-INGS printed on the inside. It was signed *Grant*. I looked at the envelope again for the surname, trying to remember who Grant Hopkinson was, when a photograph I hadn't noticed previously fell out of the envelope and at last I recognized who it was from.

The photograph was a naked shot of a guy I had tricked with a few months ago, in an amateur porno-style pose where he's grabbing his dick low to make it look bigger. I hadn't given him my address, but as we'd had sex at my apartment after meeting in some bar (probably Splash), he must've taken note of the building and apartment numbers and my last name on his way out. We hadn't exchanged phone numbers

to see each other again, but he'd written his phone number on the back of his photograph, I guess in case I changed my mind and wanted to have another round of sex with him. The photo wasn't bad, and from what I remembered the sex had been fun enough, but I figured he must be a lunatic, and the whole manner of his trying to reconnect like this, in a Christmas card, without even a real note attached, turned me off to the idea of seeing him again.

I tossed the card aside but kept the photo. I unbuttoned my pants and pulled out my dick, working it until I had an erection. I grabbed my dick low along the shaft and tried to mimic the porno pose of Grant's photo. What is it that makes us so desperate sometimes to be seen as pornographic? I wondered. Is it a genuine desire to be an exhibitionist or do we rather crave to be desired by as many men as possible and seek to achieve that aim through exhibitionism? I looked out the window and thought about my neighbor I hadn't seen for so long now. What he and I had shared across our alleyway was a private moment between the two of us, even though any of our neighbors could very well have been watching us from their windows—uninvited participants in the spectacle of our intimacy.

He was there again now, watching me as I aped Grant's photo. I smiled at him, waving my dick at him in exaggerated fashion. He waved his back. His pants were already tugged down around his knees, although he still had on a flannel shirt. His dick poked out from between the two flaps of fabric, like the lever of a slot machine. I wanted to tug on that lever again and again like an addicted gambler until I won the prize. But I was too far away to even reach the handle, in much the same way that the jackpot always eluded the gambler, the dream, the aspiration that kept him coming back because he couldn't have it.

But in a way, I already "had" my mysterious neighbor, possessed him, even though we had never touched, never kissed, never felt our bodies pressed deep inside each other. I pulled long and hard on my cock, watching him, enjoying that we both were jerking off expressly for each other, that we had this curious connection from across the divide that separated us. Only in New York, I thought—although I imagined it was possible that these sorts of encounters did occur in other places. But what was transpiring between us, this relationship, was something that seemed to define the wacky nature of life in New York, a city where these sorts of interactions were

more-or-less commonplace.

I came first this time, spurts of cum splashing against the window pane and falling onto the cushion. I'd wash it later, I thought briefly, flexing my arm again and again to milk the last drops from my dick, not wanting to stop for anything. I kept my eyes on my neighbor as I came, smiling back at me; I felt I had his undivided attention, he wasn't thinking about what to make for dinner later or whether he had paid the electricity bill yet. He was just watching my body, the sex we were having from across our separate buildings, and enjoying the sensations of his own masturbation playing out what he could only fantasize about from across the split.

When my body stopped trembling, I leaned forward and kissed the window, making a pucker print against the glass. I watched my neighbor, who was still jerking off, but I was in no rush for him to come quickly. I was half afraid that if he did, I would never see him again—even though he lived next door to me. That, too, was something so New York; there were people who lived on my own floor who I'd never seen in the three years I'd lived here. I studied his body, the way he moved, the way he jerked off. He leaned forward and let his tongue hang down, wagging it as if

he were trying to lick his own dick. I wanted to lick it too. He let a glob of spit fall from his lips, catching it right on the head of his dick and then using it to lubricate his fist.

He came quickly with the lubrication, and I filed that little datum for future reference, as I continued to watch him. He brought his fingers to his lips, licking the cum from them and sucking on his index finger as if it were a cock. As if it were my cock, his eyes locked with mine. Then he grabbed his dick again and waved it at me, a farewell, before disappearing into the far recesses of the room.

I lingered in the window staring out across the alleyway, enjoying the warmth of the radiator below me and the afterglow of orgasm, thinking about these two encounters with my neighbor and wondering how soon it would be before I received my next Christmas card.

~

My mailbox remained empty of cards for many days on end, and I began to feel nervous—although the truth is I didn't usually get that many cards. I'm a bah-humbug sort of guy and used to think of them

only as a nuisance, those obligatory cards from clients and all, but now I was desperate for them. Time was trickling by quickly—soon Christmas day itself would be upon us—and what if I never saw my window buddy again after Christmas had passed? We seemed to have a magical connection only if I had a Christmas card from some past lover or trick. I looked at the row of cards I had placed in the window around the window seat; they formed a sort of Advent calendar, marking off the days/encounters we had had together.

I took some comfort in the fact that I had not yet sent my own cards, and I hoped there were others like me, who waited until the last minute, whose cards would arrive after Christmas day itself. I also hoped that there might be cards that were en route but were delayed by the sudden general increase in mail volume.

What would happen when I stopped getting Christmas cards altogether, though? Would we ever again connect? What would happen if we met on the street? Would there still be the same sexual tension between us in person? Or was there some extra glamour that came from being connected across such a distance, like the emotional safety of jerking off to a

picture of your boss in the privacy of your home, fantasizing about him in a way that when you were in front of him in person you couldn't imagine ever realizing, because he seemed so unappealing in the flesh.

On the afternoon of Christmas Eve I came home to find a card in my mailbox at last. It had no return address, so I didn't know who it was from, but that hardly mattered. My dick leapt to attention as I stood in the hallway in front of the mailboxes, contemplating what should transpire when I went upstairs and opened it. My libido was well trained now to produce this Pavlovian response.

I distractedly waited for the elevator, having to make pleasant small chat with the Irish mother of three who lives two floors below me, who kept going on about how excited she was that her brother had come to visit for Christmas and other inanities. Alone at last in the elevator after the 4th floor, I breathed a sigh of relief and leaned against the fake wood-paneled wall, squeezing my crotch with one hand and adjusting myself within my pants. The card was addressed to me as Mr. Bowes and the postmark was from within the city; I had no clue as to who it could be from.

I dumped everything on the couch as I came in and hurried over to the window seat, tearing open the envelope as I went. The card showed a naked hunk, with a Santa's hat over his crotch. I opened it. It was a blank card, in that there was no pre-printed greeting, just a hand-written note from the sender, which read:

> Hi, my name is Robert. I live across the alley from you. I looked your last name up on the buzzer, guessing which apartment was yours. I hope I guessed right! I like what happens when you get a card. If you want to let that happen with me, give me a call sometime.

He'd signed the card with his phone number.

I ran one hand over the hard bulge in my crotch and looked up. In the window across the alley was my neighbor, Robert, watching me and smiling. I smiled back, put his card on the window sill, then got up to look for the phone.

The Story of O. Henry,
or,
The Gifts of the Leathermen

Simon Sheppard

One hundred and eighty seven dollars.

That was all the ready cash Jim and Del had between them, and Christmas was on its way. Since Master Jim's corporation had downsized, he'd had to take a promotion and pay cut, and times for him and his slave Del had been tough. Now the holidays were coming, and all the cash in the house came to one hundred and eighty seven dollars, and the bills from

the gym, the cable TV company, and their Internet service provider were yet to be paid.

Slave Del sat at home, naked and disconsolate. He'd finished cleaning the dungeon and polishing his Master's boots, and now he had time to think. Christmas would be here in two days, and he hadn't bought a present for his Master. He knew what he wanted to get him, of course. A black-leather jacket. *The* black leather jacket, to replace the one that had been stolen.

They'd been at a play party in October when the theft occurred. Master Jim had been magnificent in his full leathers: form-fitting chaps, gleaming studded harness, knee-high boots, and black leather motorcycle jacket, a matched outfit all made by The Leather Man, the city's best purveyor of fine leather goods. They'd cost a pretty penny, all bought in the days when Master Jim was still a highly-paid executive with his own custom-furnished office and impossibly cute office-boy. The jacket had been stolen while Del, naked but for his broad leather collar, had been firmly bound to a Saint Andrew's cross. His Master had been working him over with a brutal single-tailed whip, raising welts and bringing forth cries of ecstasy. It was warm for October, and taking his

boy to his limits was hard work for Jim, much harder than it had been when they'd signed the contract and Del's limits had been much lower. Master Jim had worked up a sweat. He'd laid the whip down for a moment and peeled off his shining leather jacket, folding it carefully and placing it in a corner near the cross. He'd picked up the whip again, stood just behind his slave, and pressed his bulging leather cock-pouch into his boy's butt. "Are you ready for more?" he had whispered into Del's ear.

Del had turned to look at his Master. His eyes were filled with love, tears, and respect. "Oh, yes sir. Please, sir."

Intently, raptly as an eagle, Master Jim had aimed the whip's stinging tail at his slave's aching, bleeding flesh. The wounds, holy as stigmata, made his boy's broad, muscled back even more beautiful. Again and again, he had brought Del to the point where the slave thought, no, Del *knew* he couldn't take it any more. Master Jim would back off, let the boy catch his breath, then started in again, taking them both to new peaks, higher plateaus, a mountain range of ecstasy. When it was over, and Master Jim had unshackled Del and gathered him into his embrace, he glanced over Del's shoulder at the corner where

he'd laid his jacket. The corner was empty. The jacket was gone.

No one in the crowd had seen anything. They'd all been watching Jim and Del. The thief was never found. Jim had taken up wearing an older jacket, well-broken-in but nowhere near as magnificent as the one he'd lost. And for months Del had been longing to be able to buy his Master a replacement.

And now Christmas, the time for exchanging gifts, was near. The slaveboy knelt on the carpet, remembering the scene, the feel of the lash. His dick was hard, pulsing up against his belly. Unable to afford a new jacket for his Master, Slave Del was sad, and he did what he often did when he was sad, reaching down to his cock for consolation. Del felt fortunate; the terms of his contract with Master Jim permitted him to masturbate in his Master's absence, as long as he thought only of Master Jim, and as long as he was fully ready to service his Master on his return. It was only two o'clock, and Master Jim wasn't due back till five-thirty. He'd have no trouble getting it up again by then. He'd be more than ready.

Stroking his cock with his right hand, Del reached up to his nipple ring with his left, tugging at it, sending delicious jolts of sensation through his tit. It felt

so good he let go of his stiff, slightly curved dick and grabbed hold of his other nipple, working his nipple-flesh against the thick gold rings. He thought of his Master working his tits so hard they burned, slipping ropes through the rings, stretching his flesh, making him feel so very, very good. His hands let go of the precious rings, moved down over his lean belly, down to his warm, shaved crotch. His right hand grabbed his dick again, his left wandering down over his big balls, the sweaty ridge between his legs, down to the comforting wet heat of his hole. Just the merest touch caused his well-trained ass to dilate.

He squeezed his dickhead against the metal of his Prince Albert. The chunky ring through his dickhead wasn't gold, like his nipple rings; his Master had been demoted before he'd bought him a pure gold replacement for the surgical steel ring. Still, the piercing was fun to play with, to play with hard. A pearly drop of pre-cum glistened where the ring entered his piss-slit. Slave Del pressed his finger up into his butt, drew it out to cover it with spit, then slid two fingers all the way in. It was, of course, his Master's hole, his Master's to fuck, to fist, to own. But, as his fingers plunged in and out, in and out, he was grateful for the loan.

He was working his dick with his whole hand now, his long foreskin almost engulfing cockhead and ring, then peeling back again to reveal shiny, swollen flesh. It was something of an effort, when he was this close to spewing spunk, to keep his mind only on his Master, not to think of those other men he'd seen and desired, but was not permitted to touch. It was an effort, but he made the effort, and he succeeded, more or less, and he was glad he did. His fingers hooked back to give his prostate a jolt. He closed his eyes, murmured his Master's name, and shot a creamy load from his stiff cock, from the slit where the silvery ring lazily glittered. He opened his eyes. On the little Christmas tree in the corner, multi-colored lights twinkled happily.

After wiping up, Del went cheerfully to work, laying out his Master's chaps, harness, and boots, gleaming black leather arrayed in anticipation of Master Jim's return. He felt a familiar tingle of happiness, knowing that the man who owned him would be back soon. If only he could afford to buy another jacket to match those beautiful chaps. What a surprise for his Master that would be! Just the thought made his still-damp dick stir a little bit.

The slaveboy was in the kitchen, chopping vegeta-

bles for gazpacho when he heard the car pull up the drive. He rushed to the door and knelt on the carpet, face downturned, hands clasped behind his back. The door opened. Master Jim stood before him. Wordlessly, he untied and pulled off his Master's shoes, peeled off the dress socks, and kissed his Master's warm, moist feet.

"Hello, boy," said Master Jim.

"Hello, Sir."

"Undress me."

Del carefully removed his Master's clothing, hanging up the suit, neatly folding the shirt. Master Jim's muscular, hairy body was completely naked.

"And now, Sir?"

"My leathers, boy." The ritual was the same every night.

Del put the harness on his Master's powerful torso, dressed his Master in the form-fitting chaps, put thick woolen socks and gleaming boots on his Master's feet.

"Did I do well, Sir?"

"Very well. I did a good job training you."

Jim looked down at the naked boy kneeling before him, and his heart was filled with affection. The smooth, young flesh that was his property. The broad,

studded collar. The heavy gold rings hanging from the boy's pierced nipples. The chunky ring through the head of the boy's hard, quivering dick. Someday soon, when the household's finances improved, he would buy a solid gold ring to replace that steel Prince Albert. Gold: a sign of the esteem in which he held this boy whom he owned body and soul.

Master Jim's weighty cock jutted half-hard from the front of his chaps.

"Suck my dick, slave," he said.

~

The day before Christmas dawned cold and clear.

Del spent the morning putting the last touches on the house's decorations: a few silvery bells here, gossamer angels there, a sprig of mistletoe above the bondage table in the wreath-festooned dungeon. And all the while, he fretted over buying a Christmas gift for his Master. The jacket. He wished with all his heart that he could buy the jacket. If only he had the money... But what did he, another man's property, have of his own to sell? Not even his body was his own, only the piercing rings his Master had given him as a symbol of his servitude.

The rings!

An idea came to Del.

The contract permitted him a mid-day shopping trip while his Master was at work. He dressed in jeans, a T-shirt, and work boots, pulled on a battered leather jacket, and headed out the door.

~

The shaved-headed boy behind the piercing shop's counter smiled at him, tongue-piercing winking in the fluorescent light.

"Well, it's not the kind of thing we usually do, but since it's the day before Christmas and all... 'Course, I can't give you as much as they were sold for, but...If they're not damaged or anything, I could re-sterilize 'em and re-sell 'em, maybe. And it is the day before Christmas..." He pulled at his distended ear-lobe. "Okay, c'mon."

Once Del was lying on his back on the piercing table, it only took a few moments for the sales clerk, Chaos by name, to use his pliers to open the nipple rings and slip them from the piercings.

Del felt naked. Being stripped of these tokens of his Master's ownership made him want to cry.

"Okay, all done," Chaos smiled. He laid his hand on Del's upper thigh, just millimeters from his basket.

The piercing boy, with his tattooed scalp and face full of metal, was cute enough, but Del belonged to Master Jim. "Then I'll take the money, please." Del was in a hurry; he still had one place to go.

"Okay," Chaos said. He stuck his tongue out slightly; the metal ball of his tongue-piercing gleamed like a Christmas-tree ornament.

~

Once Del had set the sale-priced turkey to thaw in the refrigerator, he wrapped the gift he'd bought for his Master and set it beneath the little tree. He grinned in anticipation of the happiness he'd see on Master Jim's face when the silvery wrapping paper was ripped away. He was glad they always opened their gifts on Christmas Eve; he'd have had a hard time waiting till the morning.

But a sudden thought ruffled his happiness. What if his Master was angry at what he'd done? Master Jim was understanding, but he could be stern. It might be wise not to let him know the nipple rings were gone until he'd had time to explain, until Master Jim had

seen his elegant gift. He pulled on a T-shirt and, naked from the waist down, spent the rest of the afternoon tidying up the house.

At four-thirty, dinner was well underway and he went to his Master's closet to fetch Master Jim's leathers. When he opened the closet door, a sudden jolt ran through his body. The chaps were gone, the hanger where he'd left them the night before dangling empty in the twilight's gloom. What could have happened? His Master would never wear them to work. The bedroom window stood open. Had Del left it that way, or had a thief crept in while he was away?

The slaveboy's throat tightened, thinking of how angry his Master would be at finding another piece of his leathers gone, and the rings gone from his slaveboy's nipples. His Master would feel betrayed. Del knew with sickening certainty that he was unworthy of servitude. He wouldn't blame Master Jim if he threw him out on the streets.

With trepidation, Del laid out the harness and boots and knelt, his mind racing, waiting for his Master's return.

At last, after what seemed like hours, the front door opened. Del could already feel the pain of his Master's disappointment, a punishment harsher than

the heaviest blows. He could take anything, he'd been trained to take anything, anything except the loss of his Master's loving power.

Master Jim strode to his kneeling slave.

"Hello, boy."

"Hello, Sir."

"Undress me." Master Jim hadn't said a word about the missing chaps; he must not have noticed yet. "But first, take off that T-shirt. Did I tell you you could wear a T-shirt?"

"Yes, Sir. No, Sir." Del shuddered as he drew the shirt over his head.

Jim stared down at his slave's naked chest. "What happened to your nipple rings, boy?" His voice sounded cruel, baffled, and hurt, all at once.

Del winced. Tears came to his eyes. "Please don't be angry, Sir. I did it for you, Master. Please let me explain."

"I'm waiting."

"May I rise, Sir? And get your gift?"

"Do it." Jim's voice was stern.

Del walked to the tree, fetched the heavy, foil-wrapped package, and took it back to his waiting Master.

"Merry Christmas, Sir."

Master Jim took the gift.

"May I see your face, Sir?" He'd not yet looked into his Master's eyes.

"You may, boy," Jim said as he unwrapped the package. Inside was a new leather jacket, a perfect match to the one that he'd lost.

"Thank you, boy," he said simply, but the happiness on his face made Del's heart leap with joy.

"I sold my nipple rings so that I'd be able to afford it, Sir."

"I understand."

Del, in his happiness, had forgotten about the missing chaps. He held his breath: how could he tell his Master?

"Sir..."

"Yes?"

"Your chaps, Sir..." he stammered.

"Ah yes, perhaps I should have told you, so you wouldn't be concerned. Like you, boy, I couldn't afford the gift I wanted to give you. So I sold the chaps, and used the money to buy you this." He reached into his jacket pocket and pulled out a small, gaily-wrapped box.

Del tore away the red-and-green paper. A jewelry box. He flipped open the lid. Inside lay a thick gold

ring, beautifully wrought. A ring for his dick. A ring that perfectly matched the nipple rings that were no longer his.

"Merry Christmas, boy."

"Oh thank you, Sir, thank you." Not waiting for permission, he threw his arms around his Master and kissed him hard on the lips.

"You're welcome, boy," Master Jim smiled. "But you've disobeyed me by selling the rings without my permission, and for that you'll have to be flogged."

A broad grin lit up Del's face. "Oh, yes, Sir. THANK YOU, Sir!"

~

For hours Del had been hanging suspended in the dungeon, leather wrist restraints chained to a hook in the ceiling. His Master had threaded twine through the empty piercings on his chest and tied it off to the overhead hook, so that every time Del's body jerked in response to a blow, a painful tug at his chest reminded him of his disobedience, and of their mutual love.

Master Jim had started slow with a suede flogger, warming up his slaveboy's back and butt. But in time

he switched to a heavier bull-skin flogger, then to a braided cat o' nine tails that raised searing red welts on Del's naked flesh. The escalation of pain sent the slave deeper and deeper into an ecstasy of submission, until his dick was aching with cum. At last, Master Jim put down the whip, grabbed his own cock, and pissed all over his boy's bruised and bleeding back. The hot sting made Del scream from between clenched teeth. Master Jim shook the last few drops of piss from his dick, and tenderly stroked Del's hair.

"I'll be right back," he said, and left the dungeon.

And within a minute, the electronic music that had for hours throbbed over the dungeon's speakers were replaced by the chanting of nuns, singing hymns of praise written by a 12th-century French abbess. Del had thought he couldn't go any higher, any deeper, but the ineffably gorgeous music made his spirits soar, rising on the wings of angels to a paradise of devotion and bliss.

It was late on the night before Christmas now, the time for Santa Claus to come and deliver his gifts. But Del the good little slave boy knew that, for him, Santa was already there.

Lumberjack

Christopher Marconni

As night fell, so did the snow. It was one of those sudden December blizzards, the kind that gets you in the mood for Christmas (ready or not). So I went to the local nursery to see what decorations they had.

The store was pretty deserted due to the weather. I knelt down at the end of an aisle to look at the fake miniature trees on the shelf. Apartment life is tough when you can't even have a real Christmas tree.

I could hear that somebody was stocking the shelf right on the other side and then a big leg moved slightly around the corner. I couldn't see the face—all I saw was construction boots, baggy jeans, and a

huge bulge in the crotch of those pants. He had to be hard, I thought. One other thing stuck out: even though his jeans were dirty all over, there was a noticeably dark stain of dirt on the denim that stretched over his bulging crotch.

The guy must not have realized that I was right around the corner because he was mumbling to himself and every few seconds he would reach down and rearrange his massive mound. I didn't make a noise and I couldn't take my eyes off of that oversized load of his. I mean, the size of it was enough to make anyone notice, but the fact that it was also highlighted by dirt was just another attention grabber. My face was just inches away from it and by this point I didn't even care what his face looked like.

Just then he walked around the corner and knocked me over with his crotch. For a split second, my face sank into his dank, overstuffed basket, and then my head hit the floor with a thud.

"Oh man, I'm sorry." He bent down over me to make sure I was okay. "I didn't know you were there. Are you okay?"

He must have thought that I was in a coma, because once I looked up at this brute towering above me I was helpless to move. I couldn't find any words

and my eyes must have been glazed over. He looked like a high school kid on steroids, complete with a baseball cap with the nursery's logo on it. The name sewn onto his work shirt was Jack.

"Hey, are you all right?" Jack asked again. "Your eyes are open." He was close enough that I could taste his smoky breath as it blew down on me. He reached over and gave me the obligatory light smacks on either side of my face. I stared up at the thick swirls of brown hair that pushed out from under his cap in the front and on the sides. He was the kind of guy you could spend a month looking at and you still wouldn't feel like you've absorbed all of him.

Heavy footsteps approached us. "Jack, what the hell's wrong with you?"

I started raising myself up from the floor as Jack nervously tried to help get me up quick.

It was Al, the manager (or so his shirt read) and he was pissed. "Jack, that's the third time this week you've knocked somebody over!" Al brushed the dirt off of my jacket. "You all right?" he asked.

"Uh, yeah, thanks."

Al glared at Jack while speaking to me, "Why don't you pick out any tree you like, free of charge. Jack will help you out." I nodded my appreciation.

Then he smacked Jack in the head. "And why don't you watch where the hell you're walkin', huh? You klutz, you're gonna put me out of business at this rate!"

Al walked away and Jack dropped one of his big bear paws onto my shoulder. "Whew, I thought I was a goner that time for sure." His other paw reached down and manhandled his manhood. "Hey, again, I'm sorry. Now let's find you a tree."

I lagged behind a little so that I could watch his wide muscle butt swing from side to side. He looked like a young lumberjack but he walked like a wrestler—primitive and territorial.

"What's your name, bud?"

"Chris." It's funny—he had the body, the swagger, the macho looks, but he didn't act like an uptight straight-ass, with all of that check-me-out and you-ain't-nothin' bullshit that some tough guys like to radiate. I felt more comfortable than I normally would around someone of his caliber. Even a little bold. "So you live around here?"

We stopped at the tree lot outside. He lit a cigarette and scratched his crotch. "I go to the university downtown, so I live with a couple of guys in the dorm."

I had visions of him lounging around in the dorm room in nothing but underwear. My prick started getting hard instantly. So I lit a cigarette and looked around at the trees. I picked one out and Jack carried it back into the store.

I bought all sorts of shit for it—a stand, decorations, lights, the star. But at least the tree was free. When we walked out to the parking lot with everything, it dawned on me. "Oh man, this thing isn't gonna fit in my car!"

Jack spoke through the branches, "Oh, don't worry about that. We deliver 'em to your place for nothin' as long as you live nearby. Do you?"

"Yeah, just a couple miles away."

"Great, let me run in and tell Al I'm leaving. It's closing time anyway."

Jack came back and loaded the tree into his pickup truck (of course he had to drive one of those) and then he followed me along the snow-covered roads back to my apartment. My pulse was racing at the thought of this stud in my place. I was also mentally scanning my living room, trying to remember if I had any gay stuff lying around and wondering how I could hide it before he saw it.

We got everything into my apartment and Jack

leaned the tree against the wall. "Wow, nice apartment. You live alone?"

"Yeah."

"You're lucky." He rearranged his bulge. "I thought most apartments didn't let you have live trees."

"Oh shit—I forgot about that."

Jack snorted a laugh and started scratching himself again. My eyes were glued on his big hand roaming over his even bigger mound. "Oh well, we'll just set it up away from the windows."

My hardening cock was a good reason to leave the room and get a couple of beers from the kitchen. But that sidetrip did me no good—Jack had taken off his work shirt and a flimsy t-shirt was all that covered his burly chest when I came back into the room. I could see everything through it: his hairless chest, his massive pecs, and the quarter-sized nipples that hung down from them, as well as his slight belly. Even more impressive were his torpedo-like arms splitting out of the sleeves. All of that bloated muscle made him look like a giant in a child's shirt.

I tossed him a beer (like I knew he would have done) and then I just said it. "Man, you got a great body." I didn't think it was that strange to say.

"Thanks." He downed half of the beer and belched. "I don't work out, but this job keeps me in pretty good shape."

He walked over and fit the tree into the stand. When he backed away to check out whether it was in there straight, I noticed that his hands were covered in mud from the tree. Once again, he reached down and palmed his pecker. It dawned on me that this guy touched himself constantly without even realizing it, and that's why his bulge was smudged with dirt. I stood there in awe as I watched him unintentionally smear mud over his giant protrusion again and again.

"Well, there you go, bud," he said. He downed his beer and grabbed his shirt.

My heart sank, I wanted so much more. Trying to sound half-kidding I said, "Don't you wanna help decorate it? I could order a pizza." I heard the words and I thought they sounded lame.

"Naw, I should get back to the dorm before this storm gets any worse."

I couldn't blame him, the weather was getting bad outside. So I thanked him and he apologized once more. Then he scratched himself, wished me a Merry Christmas, and closed the door behind himself. I sat down on the couch, unzipped, and started stroking

my stiff rod. He ruled my thoughts completely, and I knew I had to take care of my dick immediately before I'd be able to think again.

A minute later there was a knock on the door. I put myself back together and answered it. There stood Jack with a sheepish grin on his childish face. "Is that offer still open?"

"Sure, get in here."

He took his coat and work shirt off again. "I was thinkin'—we aren't allowed to have a live tree in our dorm either. It just hasn't seemed like the holidays without one." He moved his bulge around. "So I thought, what the hell, gotta get some Christmas spirit somewhere, right?"

I ordered a pizza and Jack got some more beer from the refrigerator. He started unwrapping the stuff I bought and I just watched him: the way he nodded his approval or shook his head with each ornament he pulled out of the bag. A string of lights cascaded down to his wide lap and I wished I was that one damn bulb resting atop his mountain of manliness. I realized that he couldn't have been hard all this time—his cock was actually at rest. I also knew there wasn't a gay man on this earth that would turn away from this dude.

The pizza arrived before we even got started decorating the tree. Jack reclined on the couch across from me, legs spread, feet up on the coffee table. We talked about his job, my job, his courses at college. No matter what the topic, though, my eyes were fixed on his incredible, stocky build. He wolfed down the pizza like an animal. He chewed, slurped, and swallowed with all the intensity that I would use if I given one chance at his body. I ate, but I didn't feel full. I was ready to eat the shirt off of his sweaty torso.

He got up first and belched. "I'll get us some more beer." I went to the bathroom and when I came back he tossed me a brew (like I knew he would). I went into the kitchen to get some water for the tree when I heard him say something about an extension cord. When I walked back into the living room I almost shit.

Jack must have opened the coffee table drawer to look for a cord and there he stood, holding a gay porno movie in his hand. I didn't know what to do—it was already too late. He rearranged his bulge while he scanned the photos on the box. "This is wild shit."

I walked over and took it from him. I tossed it back into the drawer and wished I could disappear. I fully expected him to run, but instead he smacked

me in the shoulder and laughed. "Hey, it's no big deal."

"No?" I sensed he was just trying to smooth out a weird situation.

"Naw, it doesn't bother me, really."

And that was that, so we got busy with the tree. Of course, as we worked on it, I did catch him staring at me from time to time. It was almost like he was trying to find the clues he obviously thought must be there, the ones he hadn't picked up on earlier.

After another round of beers we were both feeling pretty loose. The point when I came undone was when Jack was standing in front of me lighting a cigarette as I was sitting on the floor testing out another string of lights. Yet again, he reached down and adjusted his basket, right in front of my face. When he glanced down and saw me staring, I think it was the first time he realized what he so unconsciously did with his crotch all of the time.

I didn't even return his glance, I just reached out my hand and started slowly rubbing Jack's monstrous lump. The instant my palm felt the humidity of his crotch, a slow shiver pushed up through my body. My fingers massaged the length of his huge dick up to the head, and then back down to cup his heavy balls.

Jack didn't say a word. But he smoked his cigarette differently than before. Every time he exhaled, he blew the smoke out with a quiet but deep growl. When I looked up to see his expression, his head was thrown back and his free hand was slowly roaming over his expansive chest.

Beer tends to make me a bit of a tease and this time was no exception. Feeling like I had whet his appetite, I took my hand off of Jack to see if he would take the next step. He looked down at me with a big question mark on his forehead. I kept my blank, dumb stare going.

Jack didn't know what the hell to do next. His idea of initiative was to step forward so that his growing basket was almost against my nose. I just stared at it.

Finally, Jack's urges moved him into action. A big hand grasped me by the hair and guided my face into his crotch. The moment my nose and mouth connected with that bulge, I could feel him punch his hips forward to get me in faster. With the ice most definitely broken, Jack used both of his hands to move my face all around every steamy slope of his sexual equipment. The smell of his dirty jeans combined with the potent worked-all-day scent of his crotch put me into an altered state of mind. His

growls grew louder as my teeth gnawed at the denim that kept me from his nuts. I frantically reached up and started fiddling with his zipper.

"I gotta go," he said, and grabbed his shirt and coat. He was out the door in a flash. I couldn't believe it! We had been so close and he was really getting into it. Or so I'd thought.

Then, another faint knock at the door. I opened it and Jack was looking at the floor. He opened his mouth to say something but I just grabbed his arm and pulled him in. "Oh just get the hell in here and get those damn pants off!"

When I first saw him, I would have never dreamed that I'd ever be in the position to order him out of his pants. Or that he would actually follow such an order! But there he was, tossing his shirt, kicking his boots off and stripping out of his jeans like a hyperactive kid.

Gasping, he asked, "Now what?"

"There isn't a script here, bud." I went and got some more beer. Then I dropped to my knees before this god of masculinity. "Jack, you are so fucking hot. I just wanna eat you alive."

He moved my face into his white briefs and let me take it away from there. My tongue wasted no time

soaking his underwear with an endless supply of saliva. His thick cock was growing to gigantic proportions. I dropped down lower to chew on his balls. Jack pushed his hands all through my hair and moaned, "Oh man, you're a wild fucker!"

Somehow my head ended up behind him and I got my first good look at his muscle butt. The white briefs stretched tight across his meaty buns. Jack's legs were thick and powerfully muscular, covered with fine brown hairs. I tried kissing his ass but I just couldn't take it anymore. I grabbed his underwear and ripped it off of him. He peered down over his shoulder but I was gone. My open mouth shot right into his furry ass. Jack's entire body quivered as my tongue landed at the top of his crack and started a slow, wet descent downward. "Shit, Chris, what are you doin' down there?"

I was sure this was new to him, but I noticed he certainly wasn't discouraging me. When my hungry mouth reached his hole, his butt muscles tensed up around me. I knew that wouldn't last for very long. I pushed my tongue past his hairy barrier and circled it around the puckered opening. Growls rumbled throughout his body, and then he opened up completely. My tongue lunged in as far as it could and

scoured his inner walls with wet passion.

Jack went numb and sank down onto my face until I was flat on my back with him sitting on my head. Once his desires hit a new high, he hopped up off of me and started ripping my clothes off. My cock stood straight up in the air, throbbing impatiently.

Jack knelt over my face and leaned down to better examine my prick. I could tell that he was unsure of what he wanted to do. He started stroking me but his face was so close that I knew he wanted to try sucking it, but he was too timid. I sure wasn't. I pulled his dick down into my mouth and swallowed all I could. Every slurp I gave made his veiny prick grow even further, until the sides of my mouth were stretched to capacity.

Once I started my feverish rhythm on his pecker, he jumped into the action himself. He started off just licking my swollen cockhead. I raised my hips up off the floor to sink my dick into his mouth, but he made it clear that he was on his own schedule. So I let him follow his own pace. After all, I wasn't exactly unhappy at this point. I was more than willing to just lay there and suck the sap out of this lumberjack's tree.

Eventually Jack's mouth was sliding up and down

my stiff pole like a pro. My mouth was getting sore by this point, so I pulled off his cock and started sucking his weighty balls. I could only get one into my mouth at a time, the other one hung heavy against my cheek. His sack was so damn heavy that I was convinced that his balls were made of granite.

Whatever they were made of, Jack definitely liked a lot of attention paid to them. I bit, chewed, and slobbered all over his flesh while he mumbled things I couldn't understand. But I got the gist of his appreciation because he kept rocking back and forth, slamming the other nut against the side of my face.

After a bit, we both seemed ready to make a shift in positions. I slid out from under him and swiveled around, headed for his stocky chest. Jack was still kneeling as I planted my mouth on one of his large nipples. I licked and bit until it stood erect. Jack started stroking his dick and said, "Oh yeah, man, keep it up." I switched to his other nipple and bit hard. Jack growled, "That's right, bud."

I felt like I was in some fantasy dream with this guy. My tongue glided across his wide, smooth chest and dove into his damp armpit. I drank down all of his sweat and then moved to the other one. "Shit," Jack said. "You sure like guys, don't 'ya." I couldn't

get enough of him. No matter what I did to his body next, it felt like I was just beginning. My hunger was insatiable with him.

At some point during my worship session, I reached behind Jack and started prodding around his ass with my hand. He loosened his cheeks with every different angle I tried. Then I slowly tried slipping a finger into his hole. Immediately, Jack tensed and looked at me. "Uh, I don't think I wanna try that."

"No problem." I had figured as much. I mean, when you're new to the whole experience, getting fucked is pretty down and dirty serious. But one thing was for sure: I definitely wanted to get pounded by this hard stud. So, to give Jack the hint, I laid down on my back and moved my ass up to his crotch.

Jack eyed me with uncertainty. I eyed the size of his enormous prick and even I questioned myself. But I just had to have him inside me. "Condoms and lube are in the table," I said.

He reached over and got the lube. "Are you sure? I mean, it kind of isn't fair since I..."

"Oh, believe me, Jack, I want it."

He smiled and started smearing the grease up and down his gigantic tool. I took a healthy glob and

rubbed it into my hole. I had to ask, "You ever fuck an ass before?"

"Naw, I've always wanted to, but the women don't like it."

"Well, stud, then get going."

Jack threw my legs over his broad shoulders and positioned his swollen cockhead at my entrance. My ass was hungry for him, and in no time, I was completely filled to the brim with all of Jack's enormous cock and his pubic bush was tickling my ass cheeks.

"Oh, dude, this is so fucking tight." Jack pounded me slowly; I watched his face change with the sensations. My hands ran up his sweaty chest and squeezed his still-reddened nipples. It felt so hot to have this laborer's thick prick tunneling in and out of me. Our bodies were in concert.

I yanked on my own dick, but not too much because I knew I could shoot at any second. Just the sight of all that sweat dripping off of Jack made me close my eyes in order to prevent an early finale on my part. In a playful gesture, Jack reached over and picked up one of his discarded wool socks. He dropped it across my eyes and laughed. I grabbed it, moved it to my mouth, and sniffed and sucked the funk and sweat from it. I was officially out of control.

Jack reluctantly exited my ass. "Shit, I'm gonna come and fast." All at once I felt absolutely empty, but I was very near to my own explosive orgasm as well. Just then, Jack got a shy look on his face. "I know this'll probably sound weird, but, could I..." He paused and then tried again, "I'd really get off if I could come on your face."

I was floored. "That's funny—even if you hadn't asked, I was gonna make damn sure that I was on the receiving end of that thing anyway."

Jack laughed. "Well, I like to stand." And that's what he did. This giant, sweaty laborer stood up and spread his legs wide apart while I scampered up close to his crotch like some obedient child. We both whacked our meat with a feverish pitch. The view was spectacular. Jack's balls swung wildly as his veiny cock oozed a continuous trickle of pre-cum down onto my open mouth. Because his chest was hairless, his sweat just streamed downward and splashed all over my body.

Before I even realized it, I was spewing my load all over his muscled legs. Jack grinned down at me as he watched the explosion, then guided my sweaty face even closer to his musky crotch. He pushed my stubbled chin into his oversized nutsac and snarled. I

unleashed my teeth on him and his deep growls filled the room. I sucked and tugged on his huge nuts until he pulled back a little and pointed his bloated cockhead in my face.

He gripped his shaft harder and moved his flesh up and down with each stroke while I waited. "Yeah, buddy, this is what you've been waitin' for," he spat out. And then, after a long groan, Jack began to come onto my face. My shower had weaker pressure than his ejaculation! Jack bathed my face in jism, and then he really surprised me by kneeling down and licking his cum off my face. "I always wondered what that tasted like."

We finally started decorating the tree, but in the nude. I blew Jack two more times before we even had all of the lights up! And sometime during the ornament hanging, I actually managed to get a finger up his ass. By the time we were putting on the tinsel, Jack had fucked me again. Neither one of us could get enough.

When we were finished with the tree, it was morning and Jack had to leave for work. He showered and put on his clothes. Once again, he reached down and rearranged the mound in his jeans. When he saw that his fingers now had dirt on them, he looked

down at his heavily soiled crotch and honestly asked himself out loud, "What the hell happened there?" Inside, I was laughing my ass off, but Jack just shrugged and grabbed his coat.

I handed Jack my number. "Well, maybe now I won't have to go to the nursery to get knocked over by your crotch, huh?" He laughed and shook his head. I knew it would sound lame but I said, "Hey, maybe if you aren't doin' anything on Christmas you could come over here."

Jack threw a jab into my shoulder, "Christmas? Hell, that's a couple of weeks off, bud." He zipped his coat and put on his work gloves. "Better take a nap 'cause I'm comin' back tonight and I'm bringin' my laundry." I gave him a puzzled look until he growled, "I got a lot of socks that need suckin'."

No sooner did the door shut than I was out like a light.

To/From

Matthew Rettenmund

I'm thirty-one years old and I've probably slept with about two men for each of those years. Since I didn't have much sex in my pre-teens or even my teens, and didn't start doing men until I was twenty-five, that two-per-year average sounds a lot better than the reality. The truth is, I've slept around in the past six years. I've slept around.

I'm not one of these silly, sex-absorbed, flashy queers who brags about his conquests and treats sex like Oreos, one after the other. I've slept with every man who's shown interest in me—old friends, dudes met at parties, men who pressed up against me on

113

the subway—for one reason only: I'm looking for a lover, and I'm worried that if I pass some guy up for sex, I might be missing out on one.

I've racked up dozens of sex partners, but only one lover, and I was right; Craig probably never would've become my lover if I hadn't jerked him off within the first two hours after we met.

"Daddy, how did you and Daddy #2 meet?" A postmodern question I'll fortunately never have to answer. "He was visiting his friend, a neighbor of mine, and after making eye contact, he slipped into my door for a tawdry handjob and the rest is history, Pumpkin."

I know there are arguments against blending into straight society, against accepting monogamy as natural, normal, and our ultimate goal. But as long as I can remember, that's all I've really wanted. I get sick of introducing myself to guys at bars, playing cat-and-mouse, luring them home or being lured to their homes. Lured? It's more like sixth-grade square dancing—you just mechanically choose partners based strictly on physical desirability and hope that your peers don't laugh at your idea of a first-round draft.

"I love your apartment."

"I love your chest...."

The worst time to be alone is not, as some people will tell you, Christmas. Christmas, I can handle. I just hate not having a lover when I do something spectacular. I'm not a Nobel Prize-winner, or a published author, nor have I pulled some clumsy waif from a well. My accomplishments are considerably less newsworthy, but that doesn't make them any less exciting to me.

Last week, I challenged my boss. Nobody challenges Ms. Ha. Ms. Ha is devoid of conscience. She has been known to fire people at staff parties simply because she knows she'll find them there and because she doesn't believe in cordiality, sentimentality, or, well, kindness. Ms. Ha is a reptilian woman with dull brown hair and cold green eyes who somehow managed to convince a perfectly charming, almost jovial Korean guy to give her his name. If you were to cut her finger off—just theoretically—you can be sure there'd be a new one in its place in the morning.

I've been with Bright Idea for over five years, and my work has always been solid. I've never had a client outright reject my plans for an ad campaign; at most, I've had some express doubts or ask for minor revisions. But most of the time, I'm dead-on. I did that

slapsticky Elizabeth Taylor commercial where she tells the guy his wife stinks and offers him a jug of her perfume. I know it's hard to watch every ten minutes, but that scent has doubled its sales in a little less than six months. Liz hasn't been this happy since she got her second brand-new hip.

That was my ammunition in getting Ms. Ha to give me a raise. She told me I had an inflated sense of self-worth and I told her either I got a raise or I walked. She studied me carefully over an imaginary pair of librarian's spectacles (she doesn't wear glasses and is rumored to have better than 20/20 vision), pursed her upper lip, and—stop the presses—relented. I got an eight thousand-dollar raise. It was unprecedented. Unimaginable. And almost completely ignored.

None of my friends could truly appreciate this achievement because I only spoke to them once a week or so, and rarely talked about Ms. Ha like I would to a lover. They had no idea that I'd just landed on the moon. So Ms. Ha had the last laugh—I may have beaten her, but I'd done it anonymously.

But I have to let that go; I didn't have lover to excitedly talk to my raise about, so I'd just have to get one before I did something else kind of cool.

It was about ten degrees outside and I'd actually passed a snow drift that had once been my neighbor's Jeep on the way in, so I didn't much feel like going out to a bar or for Chinese-for-one. Yet I didn't have anything in the house, either. I could have had spaghetti, but I was sick of the stuff, sick of supporting Paul Newman or his charities or whoever he gives his sauce profits to... Joanne Woodward?

I was about to give up and order a small pizza when Craig called. We do that '90s thing, where you stay friends after you break up. It had been so long since we were intimate—three years—that I could hardly remember what had attracted me to him in the first place. Maybe it was the dark hair and intense eyes, the Rock Hudson jaw and shoulders, or the way his ass ski-sloped off his lower back. Maybe it was his hairy arms, his erotic, Speedsticky musk, or his singleminded determination when he used to fuck me. Or maybe it was his voice, that after-hours dj tone that made him so popular on a.m. radio—yeah, actually, that was it. "What are we eating tonight?" he asked. He always did that—just started talking about the way things would be before asking. It was our little joke, like he was constantly trying to put one past me. I crinkled.

117

"Nice try," I said, "What? You get stood up?"

He snorted. "Never. Just by you that one time." I silently rolled my eyes at the man with the memory of Operation Dumbo Drop. "I just had this intuition that you would be free on this particular night. You told me you had no plans last week, and if you don't have Ex-mas Eve plans the week before, you don't have plans at all."

"You're takeeng the Christ out of Christmas," I whined playfully. I'd forgotten—it was Christmas Eve and all through my house, not a creature was stirring, not even—well, no, I'd actually been greeted by the sight of a teensy brown mouse sitting in the middle of my sofa when I came home that night. I started thinking about glue traps and animal rights protests and rabbits with Obsession-scented eyes and almost forgot about the matter at hand.

"Oh, mmm, the thing is, I really want pizza on Christmas Eve this year," I said, "I have my heart set on pizza." I knew that would drive him away since he usually went in for fancy sit-down meals.

"Fine. Want me to pick up a couple pies and maybe show up in an hour?"

I was surprised that he was up for anchovies over hors d'oeuvres, surprised and unexpectedly...

pleased. I almost felt like we were courting, which was a newsflash to me, and would be the same to his current datemate, Peter. Peter couldn't be called a boyfriend; I take that word too seriously, in the way some people take "lover." When I think of the word "lover," I think of what an aging Gabor calls a one-night stand: 'He is vone of my luffers.'

"Great," I said. "Come on over. And, uh—we're not exchanging gifts this year, are we?" Hoping against hope since it was too late to grab him anything.

He laughed. "I guess we aren't, but I'm giving one to you. You'll like it. It's nothing major. Relax."

When that voice says to relax, your shoulders listen before your mind does. My mom used to sing me to sleep, and Craig used to talk me to sleep.

"And don't expect Peter to come, too. He's history."

I made a sympathy sound and said, "Sorry." He had no reply, so I had a suspicion that Peter had done something Major and wasn't even going to be discussed as a human being any more.

We hung up and I immediately started pacing about, looking for something I already owned that I could wrap up (in magazine tear sheets? newspapers? an A & P bag?) and present to him as new. He'd been

over since I acquired my latest batch of books... he worked at a radio station so CDs would be pointless. I settled on a small antique frame I'd found at a flea market, into which I put a photo booth shot of him and me together. I gingerly sliced it from a strip of four, then stopped to recall the day it was taken. It had been our third anniversary, right before he left me because he was too young and wanted to make sure he wasn't passing up other opportunities. Yeah, I know, I know. Might as well be a woman dating a straight guy.

We'd just made love that day, and I remember it because it was a rare mutual orgasm. We'd been lying on the bed, frantically working each other over, stroking chaotically, until I had the sensation that my hand was actually stroking my own prick, and that sent me over the edge. When I opened my eyes, I saw both our ejaculations arcing in the air at the exact same moment, and that sent another, even more powerful burst through my balls. I wound up with a faceful of somebody's jizz and Craig walked away unsoiled. The bed was worse off than my face. But it was one of those sexual peaks you think about for-ever.

I hadn't come close to achieving that since. My

next runner-up was the time I let two drunk bar-
tenders take turns poking me, and the only reason I
came so hard then was from having my prostate bat-
tered; it was hardly an emotional or psychological
thrill.

It was snowing like mad outside when I sat down
to watch TV, and to await Craig's arrival. Dusk made
the city look lavender, which was a nice thought,
politically, and which looked pretty neat, too. I didn't
bother to shower since I didn't expect anything to
happen. Except the fact that I was even aware I was-
n't showering meant I was at least thinking about let-
ting something happen.

I wondered if I could stir up the same passion
from our mutual O, or maybe even rekindle some of
the fun we'd had our first Christmas together. We'd
been so very good, so safe for a whole ten months,
and since we were both negative and both positive
that we weren't going to cheat (I was naive), we'd
decided to start having unsafe sex. I don't know if I'd
expected something momentous that night, but I
never thought we'd be so giddy, or that I'd find gid-
diness such a turn-on.

I was lying on my bed, trying to look hot and
bothered. I hadn't shaved (he loves—loved—my

scruff), I had my shirt off, I was wearing a pair of white briefs fresh out of the package, and I was sitting back so my legs were bent at the knee and my crotch clearly spread toward the door. My hairy balls were half-hanging out and probably a hunk of my cock was, too. That always got Craig hot, the illusion that he was sneaking a peek. He was always fascinated with my balls—firm and round and low hanging. I'd shaved them when he kept commenting favorably on the hairless balls of his favorite porn stars, and that had driven him wild.

He came in for bed wearing a huge grin and his padding-around-the-apartment running shorts, very tight and very old. The kind that has sheer, built-in support so you don't wear underwear. We both have jock fetishes even if we are couch potatoes outside vain trips to the gym. "You want some action?" he teased, gathering the material at either side of his cock and tugging until his erection, trapped, was outlined as clear as nudity.

I let my knees drift further apart, reaching under and around and tugged on my nuts like I had an itch. "Always."

He came up to me and pulled his shorts down and off, flinging them across the room. He was totally

naked except for his beat-up running shoes, which he left on. There was something in that gesture that turned me on, something about his unself-conscious libido, about just how certain he was that he could fuck me; I felt my boner stretched in my briefs, pulsing so hard it felt pretzeled.

His cock was pointing straight toward me—out and slightly down, like it a divining rod seeking H_2O. He's got a big one. I have no clue about inches since I never had occasion to measure it. It's just... big. It's fatter than it is long, with a mass of dark hair I used to love to sniff. I'm a sniffer. I like the way men smell, and I love the way Craig's crotch smells. The peculiar odor that his body decides to emit about six hours after a shower is like a truth serum to me, forcing me to admit I'm horny, which I always am, but which I usually mask.

"Get me ready," he said in a normal, conversational tone. No whispering or shame. But his voice is so sexy that it had the same effect as another man grunting, "Suck my cock." I got up on my knees and grasped him at the base of his cock, my fingers braced against his sensitive balls. I started by licking up and down the length of him, getting him wet, so that when I closed my lips around the tip of his wide,

flared head, it was simple work sliding down his slippery prick.

I did what he liked best: I gave my face over to a fast-paced bobbing, working almost—but not quite—friction-free up and down, up and down. I knew my curled lips were rubbing wetly against the flared head of his cock, and I knew that that made him almost uncontrollably hot.

"I like that," he growled, "Fuck—I like you on my cock, baby."

I did it so fast I didn't have time to gag as his massive meat tickled the back of my throat. I did it totally for him, but I'd be lying if I claimed not to love the taste of dick.

"No, stop," he begged, and backed half off me. My mouth followed, pinning him against my dresser. I reached behind him and felt his plump ass pressed into the handles of the drawers. He had a great ass, big and pliable, like straight guys have. So many gay guys have those perfectly sculpted buns, but I prefer the fleshy feel of Craig. I squeezed and spread his ass, feeling his moist, hairy crack, working my way toward his hole.

"You want to eat my cum?" he asked as a warning, but then he remembered we were going to be unsafe

and he shut up. Of course I did.

When my fingers reached his puckered hole, I rubbed it furiously, making it hot and wet. He loves that kind of stimulation—all on the surface, no insertion. I rubbed his butthole and continued suctioning his prong. If I'd had a third hand, I'd have reached up and smacked his pecs for him, that other little peculiarly Craig thing he likes guys to do to him.

"I'm so close," he said through clenched teeth. I kept at it, made my sucking even more deliberate. I was so hard myself it was a chore to keep from reaching down and bringing myself off. But first I wanted to eat his cum.

"Oh, man," he said raggedly. "Oh, fucking suck me—yeah!"

I felt a well of juice pouring onto my tongue as soon as he said, "Oh, man," and then had to make room in my cheek for the six or seven spurts of spunk that followed. It felt like I was holding a mouthful of live crickets the way his shots pulsed in my cheek...and it tasted a shade worse. I'd discovered that I didn't really like the taste of cum after all, but it had been a noble experiment. I blocked off my nose (and my sense of smell) inside and avoided tasting any of his ejaculate, just kept siphoning it into that reservoir

until he was done. Then I took a deep breath and swallowed it, staring directly up into his eyes, never allowing myself to show any distaste.

"How was it?" he asked eagerly, no afterglow at all.

I cracked up and smacked his ass. "Just shut up and fuck me."

He was always good for two loads in a row before his cock got hyper-sensitive, whereas with me, I can sometimes have sex and feel great without coming at all. Not that night, though.

"How do you want it?" he asked.

I pulled my underwear down to my knees, got on my belly, and raised my ass to him. "Like this."

I get turned on by that position so much. Something about the restraint of keeping my knees together, but offering my butt up. It makes my ass-hole feel so tight, makes every passage through it burn. It's like that position makes me feel every fucking inch.

For once, we didn't lose valuable time and enthu-siasm with a condom. Craig hunkered down on top of me, straddling me with his cum-slicked dick poised at my hole. I felt it ease between my half-clenched cheeks, squirmed when it sank snugly into the small area just before my sphincter. It was wildly

hot, that anticipation. I couldn't wait, and so I reached back and pulled my left cheek roughly away; his hardness was sucked into the beginnings of my hole and I felt like the happiest slut on earth.

"Knock yourself out," I panted, pushing back on him, trying to make do with almost no lube. He started wiggling his cock in circles, slipping it around in the last few drops of his cum. When it was finally in me to the hilt, he just started banging me like a convict.

It hurt without lube, but after a few minutes, my hole felt pretty slippery and there was no stopping him. He fucked me so hard the wet smacking noise on my ass sounded like I was being stropped. His balls banged against mine, and my dick rubbed against my mattress until I started blasting cum involuntarily, and with no warning.

My hole spasmed frantically around his big tool, and Craig stopped his pumping and came loudly up me. It felt surreal, like ribbons being drawn upward into me and then through my dick.

I didn't feel right down there for days.

The doorbell rang and I felt real regret at not having showered and changed into something sexy. I realized that all I wanted for Christmas was that first

Christmas we'd had together.

Craig came in with two small pizzas and his gift. He looked really handsome. He seemed older, but in a good way, and he hadn't shaved either.

We hugged, which I prolonged, as if we were still together and he was just back from a business trip or from seeing his folks at Easter.

"You'll love my gift," he said proudly.

Later, I was relieved at how touched he was at my thoughtless gift. He remembered that day at the photo booth with a little story about how reluctant I'd been to sit for those shots, in contrast to my over-enthusiasm in the resulting photos. Sitting on his lap always put a big grin on my face. I think he felt like I was reminding him of our last day together, our mutual orgasm—our relationship—which I hadn't been doing at all. Or had I?

I opened his gift. It was not, thank God, a Rolex. It was an ornament. I studied it and read the girly script on it, and realized it was an antique ornament he and I had once been given by his best friend. He'd taken it when he'd moved out. It said, "Our First Christmas Together."

I had a brief flashback to our first condomless fuck and glanced up at him. He was grinning like a

wolf, but his eyes were smiling sweetly, nostalgically.

I didn't know right then if his gift was an invitation to reignite our relationship or just a really terrific way of getting into my pants, but I decided not to look a gift horse in the mouth. If we were about to get back together, it'd happen. If not, I'd at least be spending an intimate Christmas Eve with a friendly face and the hottest cock I'd ever met.

"You shouldn't have," I said, and we took off for my bedroom. On my way, I grudgingly went to the medicine cabinet for some condoms and lube. Let's not get carried away with reminiscing, shall we?

Christmas, 1979

Jameson Currier

Denise said that Nathan and I reminded her of two choir boys lost in a candy store, an image, Nathan replied to Denise, that must have been ground into her mind because of some sort of bizarre maternal Christian self-persecution complex. But it was true that Nathan and I looked younger than we were: I with my dark, somber looks and working class clothes and Nathan with his straight, choppy blond hair and oversized shirts. And it was also true, I will readily admit to anyone, that I fell in love first with the way Nathan looked: the symmetrical squareness of his face, the thin, toy-like slope of his nose, the

light green center of his eyes—the outer ovals of which were edged the color of shamrocks. Though we were the same height, he did not share my big-boned stockiness; he possessed, instead, the lanky physique of a runner—a combination we found suited us well together in bed.

Bonded by the loneliness of the holiday, we left Denise's Christmas party together and walked up Bleecker Street to Broadway and over to Nathan's apartment in the East Village; that odd, muggy December afternoon in 1979 had blown into a clear and chilly winter night, but the moonlight now drifting in through the window beside his bed still betrayed the enchantment of a summer night.

Stretched out on his bed before me, Nathan became a willing supplicant to my desires, and it was at moments like these that I have often wished my hands were not so calloused and chapped from physical work. As my touch tested the firmness of his flesh, the taut pull of his skin, I realized I wanted more of him and I pressed my lips against the base of his neck, then ran my tongue slowly down the knots of his spine. I gripped my hands at the contours of his waist, lifted his ass up slightly and pressed my face into the spread of his cheeks. I could feel him squirm

as my tongue explored him, the fabric of his skin heating as my day-old stubble teasingly rubbed against him. He stayed there, sighing in large gasps of air, until at last he broke free and reached for a bottle of lubricant from the drawer of a bedside nightstand. He pushed me back down on the bed, but I bent forward slightly to watch as he lathered my cock with the oil and then straddled my body, his knees digging into the mattress at my waist. He opened himself first with one finger, then another, then lifted himself teasingly over my cock, until my body begged for the feel of him. Slowly, assuredly, he guided my cock inside himself. He leaned back onto his arms and I felt the desire of him flush into my lungs—my body tensed and then relaxed into a light sweat. The smell of eucalyptus from the oil he had used floated in the air above me, and Nathan appeared to enter some sort of state of unconsciousness, gently swaying, as if moved by an inner rhythm. I settled back against the bed and rocked my cock into him, as if my body, too, had locked into the same song.

We stayed that way for what seemed like forever, for I surely did not want him to stop—I felt powerful, desirable and possessed, but my mind battled with the confusing state of ecstasy my body was

enjoying, searching for an explanation for all this heightened pleasure. It was thoughts of my father, of course, that loitered about me, or, rather, the religious condemnation my father had so explicitly articulated with the grimaced spit of, "It's a sin." How could something this pleasurable be so condemned? Was sex a sin simply because it was a basic, instinctual, animalistic act? Or was it that sex between two men—raised for centuries to be such restrained and impassive creatures—was what was so taboo? Or was it that Nathan and I had so clearly communicated our desire for one another in our own subliminal, pious manner? Was that what scared so many people—the forming, as it were, of our own denomination, conceived from our own emotions as homosexuals, our own gay ethics and codes for living?

"Relax," Nathan said, as if he were indeed as much inside my head as I was inside him. He shifted his weight and we rolled over so that I was on top of him. I settled his legs against my shoulders and pressed deeper into him. This moment was the reason why I had fought so hard against myself, the reason why I became gay, this desire of being with another man. Nathan looked only at my eyes but I was caught up in all of him, the grainy feel of the hair

on his legs, the unwrinkled freshness of his complexion, the lean, athletic muscles at his shoulders. I grasped his cock, thick and stubby, and stroked it, slowly, but with a determined grip, feeling the hard, fleshy vein which circled down to the head. When I caught Nathan's gaze once again I felt that I was no longer pushing into him but he, now, was willingly pulling me deeper and deeper into himself. I shuddered and came, but I was still hard when I withdrew from him, still hard when he reached up and brought my cock together against his, rubbing them between the palms of his hands as though starting a fire with two sticks. He came the moment I took his cock in my hand again, squirming as I moved my fist up and down, warm, pearly-white liquid spilling over my fingers. I rubbed my finger across the sensitive slit of his cock, still slippery with cum. When he couldn't stand it any more, he gently took my hand and pulled it away.

Nathan fell quickly asleep—a blissful, child-like sleep—and I lay there for a while, my body wrapped around his, feeling him breathing and the blood pulsing beneath his skin, a pillow tucked underneath my head so that I could see beyond him, out through the window beside the bed onto a courtyard sur-

rounded by the dark, blocky shapes of the tenement buildings. This view wasn't much—rooftops and sooty bricks, a string of Christmas lights twisted around a fire escape one floor above—and the window of Nathan's apartment was enclosed by black iron window gates. But what caught my attention was a small, clear ornament hanging from a string that was tied to one of the beams of the grating, a tiny, tear drop crystal drawing in the deep purplish colors of the night like that of a black prism.

Aside from the bedroom, Nathan's apartment was only one other tiny room, a combination kitchen and living room which he kept in a fanatically precise order: a spice rack organized in the descending height of bottles, an alphabetized record collection, sweaters neatly folded on the top shelf of his closet. But his apartment had the feel, too, of an adult being let loose in a kindergarten playroom; his furniture was painted in bold, primary colors, bright scatter rugs covered the varnished wood floor, and even the steam radiator was painted red and white to resemble a candy cane. Near the window, the bright blue top of a drafting table was tilted upward, a pad of drawings held down by a bold yellow plastic ruler. Stacks of what appeared to be magazines on a bookshelf turned out to be

comic books; the walls were covered with framed animation cells from cartoons: Betty Boop, Road Runner, the fairy godmother from Cinderella. As I got out of bed and began to search for where I had left my jeans, the thought occurred to me that Nathan and I would never hit it off; I was, of course, his squallish evil twin, my apartment littered with tools and nails and scraps of wood, everything draped in a layer of sawdust. But this thought was also the initiation of a reflex, really, a sort of self-preserving defense mechanism—for my true thought was that if I didn't stay the night at someone's apartment I didn't attach myself emotionally, and not attaching myself emotionally, I wouldn't have to face the fear of being rejected in the morning, or, even worse, just being considered as last night's trick. I hated the morning awkwardness, hated putting myself in that vulnerable position: Will he ask to see me again or will he just kick me out?

"You're not going?" Nathan asked, his voice a syrupy, sleepy whisper. He had rolled to the edge of the bed and was watching me dress.

"It's late," I said. "I thought I could just let myself out."

"Don't go. It's Christmas."

I gave a nervous laugh. "Yesterday was Christmas. It's already the day after Christmas."

"You don't have to work, do you?"

"No," I answered. It was true—I was not scheduled to start another assignment until January.

"Then we can stay in bed as long as you want."

The thought of a night beside Nathan, waking up against him, a day of just enjoying him, pulled me back toward the bed. I undressed and slipped into the bed again, feeling first the crispness of the sheets, then the warmth of Nathan's skin as he drew himself nearer. Nathan had revealed a joyous sexuality the moment he had discarded his clothes, as if he were delicious candy which had been wrapped in bright, shiny paper. His body slipped easily against my own.

"Christmas can be tough if you're not a kid," he said, and as he pulled himself through a beam of moonlight I caught a glimpse of his face moving through a thought. "Or if you don't have a kid," he added, leaning toward me. We met in a slow, thoughtful kiss. I felt, simply with his kiss, a comfort with him that wasn't present with any man I had known before him, and I was now too delightfully awake to fall easily to sleep, though I could feel the darkness and Nathan once again settling around me.

"I bet our kids would be beautiful," he said.

"What?"

"If we were able to have kids. They'd be beautiful. With your bone structure."

"My bone structure?" I laughed with a heave of my chest and I felt Nathan move, could see him smile from the corner of my eye.

"Sure," he said and ran a finger along my cheekbone to the slope of my jaw.

"They'd probably be nervous and hyper and a psychotic mess."

"Ohhh?" he asked, drawing the word out as if it were the end of a song. "Would that be from your side or mine?"

Feeling both cautious and coy I kissed his brow, the part of him which was nearest to my lips, and whispered, "We'll let the jury decide."

He turned away from me, toward the window, but I followed him and drew my arms around his waist. "Don't you want to have children?" he asked.

"I never gave it much thought. I have a hard enough time supporting myself."

"I bet you would be a good father. You seem like the good father type."

"Good father type?"

139

"Sure. You probably should have been a doctor or a dentist. You have that kind of demeanor."

Now I laughed again and rolled away from him and, here, he turned and followed my body and encircled me.

"Do you like children?" he asked. I felt his voice reverberating to my bones.

"I suppose. I haven't exactly been exposed to them a lot since I moved to Manhattan."

"They're all around. You just don't notice them. I wasn't a very successful child—I suppose that's why I'm still stuck in the fantasy of it. My father was killed in Korea. My mother died in a car accident before I was even three years old."

As I imagined the early years of his life, I felt the walls of Nathan's bedroom expanding, blowing apart, leaving the two of us, alone, wrapped together against the infinity of space.

"She just, like, couldn't take the grief of it," Nathan said. "After he died. I can barely remember anything about them. My mother had a wave in her hair, here," he said and ran his fingers close to his left eye. "Very Veronica Lake. She had no money. Her family had no money. I'm sure this sounds sexist, but she was probably some white trash whore who got pregnant by

accident and the guy had to marry her. At least, that's what I hope, you know, so I don't have to miss her. My foster parents are really wonderful though, but I feel distant from them. I always knew they weren't my real parents."

It has always amazed me how effortlessly Nathan's life became exposed to me, layers and layers of himself unfolding as easily as the way the wind would scatter his blond helmet of hair to reveal the subtly darker colors closest to his scalp. As a boy, Nathan had been drawn to the imagination of comic books, at first intrigued by the bright colors and bold actions. He could detail specific adventures of an assortment of characters from Little Lulu and Archie to the Green Hornet and Spiderman. Comics also afforded Nathan a view of places like Gotham City and Metropolis, glimpses of exotic and enticing cities he dreamed he might one day discover for himself. This infatuation had grown into a yearning to travel and discover the world, but thus far had only led him away from his foster parents' home in upstate Connecticut to the East Village of Manhattan. Nathan was full of the big dreams of a young man—always wanting to do something like rock climbing in the Alps, windsurfing in the Caribbean, or traveling on a barge through

the Amazon. But he was not without a practical side, too. His ambition was to be an artist, an illustrator of children's books, but he knew he really did not have that sort of creative talent, that he was more imaginative in his design than in the execution of the art. When I met him he was working as a draftsman for an architect on Park Avenue, learning at night school how to draw architectural renderings—a precision he felt he was more suited for and which, in its own odd pseudo-psychological way, made sense to me when he explained it. He was an orphan, meticulously imagining the fantasy of the future.

"I always used to think that being gay eliminated the possibility of having children," Nathan said later that night, "but there are ways to have kids. I go once a month and donate sperm."

"You donate sperm?" I said, unable to disguise the shock in my voice. Nathan always reveled in my surprise; years later, we would both use it as a test for our love and concern for one another.

"Sure. There's a place in the Empire State Building. I get a big kick out of it. You go in a room and jerk off into a cup. Give it to a nurse, and then, boom, they pay you. It's fun walking down the street and thinking, well, you know, that baby could be mine."

"How long have you been doing this?"

"A couple of years. Since I moved to the city. But I don't ever hear if it was a success, you know—that someone got pregnant. The patients have no contact with the donors. But I'd love to some day have a kid of my own. I love kids—playing with kids—but I'm not sure I would be a good father."

"It would be hard raising a kid with gay parents," I said, wondering how in the world our imaginary lives had already become so complex.

"The child would not have a problem," Nathan added. "Kids can be remarkably accepting. It's the parents who need help. I don't know if I could take the responsibility of someone who was that dependent on me. I'm really too much of a flake to be good father material."

"A flake?" I laughed. "So all these women lining up for the gorgeous blond stud sperm are really in for a surprise."

"Funny, isn't it? Sort of like nature's little joke." He kissed me and drew me back again into the moonlight.

That Christmas it occurred to me that my life could encompass something I never felt possible of gay life, becoming a parent and creating a family—

believing a way of living, really, could exist beyond the diversions of the bars and parties and discos and baths. Desire came to me that night, imagining Nathan and myself as two boys who could grow old together, a pair of lovers visited on a future Christmas by their grandchildren. There we were in a room with a huge sofa and a fireplace and a tree covered with tinsel, bright-colored wrapping paper littering the thick carpet, kids squealing at the sight of games and toys and bikes. Simple but luxurious thoughts, actually, which kept lifting me out of sleep throughout the night.

The Night Before Christmas

Tom Caffrey

I'd been working as a security guard at the James Madison Mall for almost eight months, ever since leaving the Corps. Actually, since they'd asked me to leave after discovering me in the shower with my sergeant's cock up my ass and a big load streaming from my prick. Because his daddy was someone important in Washington, he came out of the whole thing with no trouble, and even managed to make it so I wasn't given a dishonorable. Early retirement they called it, except there was no good-bye party or big gold watch. Still, it was worth all the trouble to have his 10-incher in my shitter, even if it was just

that once. I was practically still coming when the MPs slapped the cuffs on me, my ass aching from the banging he'd given it.

I had some money saved up, so I'd taken the job at James Madison mainly for something to do. Most of the time, patrolling the mall was a cakewalk. During the day it was filled mainly with older couples with nothing better to do than totter around for a couple of hours buying candles in the shapes of cats and dragging their grandkids to Sears to have their pictures taken. Every so often a gaggle of teenage girls training to be world class shoppers would get caught trying to lift clothes from the Gap and I'd have to give them a scare. But usually things ran smoothly, and I spent most of my time walking around cruising the guys whose girlfriends or wives dragged them along to look at silk panties or new toaster ovens.

But the holiday season was another matter altogether. Starting the day after Halloween, every shop in the place was crammed with Christmas displays, half price sales, and anything else that might bring customers in and make them part with their cash. The whole place was covered in endless yards of red and green tissue paper, like some demented gift wrapper from the Macy's customer service department had

done the whole thing up as her contribution to the big celestial grab bag.

For eight weeks I was trapped in Christmas Hell. From the minute I unlocked the doors in the morning until the last person was shooed away when the mall closed at ten, the place was packed wall to wall with people carrying bags and boxes, kids screaming and crying, and the sounds of mall workers with painted on smiles spritzing everyone with perfume samples and announcing impromptu sales on such indispensable items as cheese logs, four-in-one tools, and ceramic gnomes that doubled as toilet scrubber holders.

The center of the holiday madness maelstrom was the mall's main court, a big empty space surrounded by food vendors that was used for special occasions like auto shows, cooking demonstrations, and other assorted galas. For many years, local religious groups had staged a traditional manger scene there, with Mary and Joseph and the whole bit, right down to the lambs made out of cotton balls and shepherds dressed in someone's old bathrobes. Then, a few years back, there had been a big fight between the church people and those who said religion had no place in a public space. Things came to a head when someone

managed to snatch the baby Jesus when no one was looking, so that when you got close enough you realized that Mary was smiling down angelically at a smoked ham with pineapple rings where a face should be.

After that, the church people had completely given up, and every since then the court had been transformed for eight weeks into this weird Christmas Land where kids could have their pictures taken with Santa. Mounds of fake snow were scattered around with giant plastic candycanes sprouting up like impossible red and white trees and the whole place was hung with flashing colored lights. The centerpiece of the whole thing was a couple of garish gingerbread-inspired houses that were supposed to be Santa's house and workshop.

To make the spirit of magical joy complete, there were mechanical reindeer and a chorus of singing elves equipped with a tape of various Christmas songs. Normally the elves were harmless enough, running through their endlessly looping repertoire of "We Wish You a Merry Christmas," "Frosty the Snowman," and the like, their robot mouths and eyes opening and closing in random order like actors in a badly-dubbed Japanese monster film. But for some

implausible reason, the tape also included the "Hallelujah Chorus," and about once an hour the elves would launch into this shrieking rendition of Handel's classic piece, sounding like a bunch of drunken drag queens performing at a Messiah sing-along, all of them fighting for the soprano parts. But people loved it, and it made piles of money, so it went up year after year.

Every day starting at noon the court was thronged with kids piled in long lines to see Santa. They'd stand for two hours or more waiting for the chance to sit on some strange fat guy's lap and tell him what they wanted for Christmas. By the time they finally got to the front of the line, they were so hyper that most of them forgot their names, let alone what they wanted. A couple of them simply threw up from the excitement. If they did make it that far, they were rewarded with a few hearty chuckles from Santa and a promise to bring them exactly what they wanted, which when the sought-after gift didn't materialize the next morning would inevitably result in a gale of tears. When time was up, a grinning elf (usually a graduate student from the university who needed the money badly enough to wear pointed shoes and fake latex ears) would drag them off, sending them away

with a candy cane and a picture to hang on the refrigerator.

The whole Santa thing bothered me, and I made it a point to stay as far away from the scene as possible. It was bad enough doing battle with the legions of big-haired women clicking madly through the halls in their high heels and clouds of sickly sweet perfume without having to contend with unhappy parents whose kids were about to explode from all the Christmas build up and who wanted to know why the elves couldn't move the line just a little bit faster. As far as I was concerned, Santa was on his own, and good luck to him. The sooner Christmas was over, the better in my book. I gritted my teeth and counted down the days until life could return to normal.

Finally it was Christmas Eve. On that night the mall turned its back on the pleading face of commercialism and was only open until seven. At a few minutes before the hour, there were still people dashing around snatching up anything that was left on the shelves. Even as shop workers were pulling down their gates and preparing to go home, people would try to run in to get something they'd forgotten. I wrestled the last of them, a disheveled woman shrieking that she "just had to get one more gift for

her sister-in-law or what would everyone say at the party," out the doors into the snow. Turning the lock on the door, I congratulated myself that Christmas was now over. With everyone gone and the lights off, the mall was eerily silent and still. All I had to do was make one last walk around the whole place and make sure that no one was still inside. Once that was done, I could go home and settle in for my much needed long winter's nap.

After checking all the stores, I went to take a quick look around the main court. The elves were silent for once, and the mechanical reindeer were throwing long shadows over the floor as the moon shone through the big skylight that covered most of the ceiling. Satisfied that everything was in order, I was just about to leave when I heard someone moving around inside one of the wooden houses. I crept quietly along the wall of the nearest gingerbread house until I was at the door. Jumping into the house, I shone my flashlight around. As I did, a figure in the room whirled around, and I found myself face to face with Santa Claus.

"Holy shit," he said in a startled voice. "You scared the hell out of me."

I stood in the doorway, not sure of what to say. I'd

expected a thief, not some guy in a Santa suit. "What are you doing here?"

"Packing my sleigh," he said seriously.

I walked over and stood in front of him, looking up and down his body from his shiny black boots to his stocking cap. "Aren't you the guy who sits here all day talking to the kids?"

"The very same," he said. Then, much to my surprise, he put his black gloved hand on my crotch, squeezing it. "And just what is it you want for Christmas this year, little boy?"

I couldn't believe it; I was getting felt up by Santa! I still wasn't convinced the guy wasn't a thief, but his hand was moving up and down my cock which, to my embarrassment, was growing rapidly. All I could do was stare at the shiny buttons on his red suit as he stroked my hard on.

"Someone has a big toy," Santa said, chuckling.

He dropped to his knees, unzipped my pants, and reached inside to pull my prick out. Then he leaned forward and sank his rosy mouth onto my nine inches. My tool sank easily into his lips as he teased the head with his tongue, flickering over the tender slit and along the ridges of my fat knob. As he sucked me, I completely forgot that he was still dressed as Santa

and put my hand on his head, wrapping my fingers in the white curls that peeked out from beneath his red felt hat.

After working the first few inches of my cock for a couple of minutes, he suddenly pushed the whole length of my dick into his throat until his nose was buried deep in my bush. His head moved forward, and I was left holding a handful of hair, the stocking cap it was attached to dangling from my hand. He looked up from between my feet, and I saw that his head was covered in short black hair.

"Now you've discovered my secret," he said. "Promise you won't ruin the surprise for the other children?"

I laughed. "Not if you keep doing what you're doing, I won't."

He nodded. "Deal."

With that, he went back to sucking my prick, his lips gliding sensuously up and down my shaft in slow strokes. He was still wearing the long white beard of his costume, and the soft white hairs tickled my cock as he blew me, sticking to my skin where his lips had passed over it. I pumped his face slowly, moving several inches of my meat in and out of his mouth. He was an expert cocksucker, and

before long I felt a tensing in my groin.

He must've felt it too, because he started to move his mouth in faster strokes, his lips pulling at my head. His hand moved up to my cock and began to stroke it as he concentrated on sucking just the tip, the leather of his glove wrapping around my prick and holding it tightly. The load in my balls was released in a single blast that blew from my cock and slammed into his mouth. His cheeks filled with my cum as I poured more and more of it into his hot throat, and he gulped several times trying to get it all down. Even then, some of it trickled from his lips, streaking the beard and the front of his red jacket with sticky clumps.

He licked his lips and smiled. "That's a hell of a lot better than the glass of milk they usually leave for old Santa," he said.

I reached down and pulled him to his feet. "Well, that's just the beginning. You haven't even started on the plate of cookies yet."

Tugging on the beard, I pulled it off of him, revealing a handsome face with a wide jaw covered in dark stubble. My hands moved down the soft red jacket to the wide plastic belt at his waist. Taking it off, I unbuttoned the jacket and slipped it over his

shoulders. There was a thick layer of padding attached to the suit, and now that it was gone I saw that underneath he had a lean, hard body. The hills of his chest were covered in thick hair clipped into a short carpet that swirled down the ripples of his abdomen, and his shoulders were broad and muscled.

"You've got a great body for a man hundreds of years old," I said.

He started to take off my uniform, his fingers slipping the buttons of my shirt from their moorings. "It's from lifting all those toys," he said, pinching my left nipple forcefully and running his tongue along my neck before slipping it into my mouth. I kissed him back, tasting my cum on his lips and plunging deep into his mouth. I could feel his prick pressing against me as I held him, my hands against his strong back.

We fumbled with one another's pants at the same time, anxious to get to the goodies inside like greedy children sticking their hands into Christmas stockings. Without taking our mouths off of one another, we undid buttons and zippers until our pants fell to the floor, followed by hurriedly discarded underwear. Once they were off and we were naked, our hands roamed over legs and asses. His burr was smooth and

round, firm and muscular beneath my hands as I cupped his cheeks and ground my cock against his.

As for his prick, it was one of the sweetest treats I'd ever seen. Easily eleven inches, the huge shaft lifted up from a set of wonderfully hairy sweetmeats that hung between his strong thighs like ornaments on a tree. Straight and smooth, his cock was crowned with a round sugarplum of a head that just begged for sucking. I held it in my hand, feeling the beating of the vein that ran along it and thinking about it throbbing in my throat. But before I could start feasting on it, he pulled away.

He flicked a switch behind the door of the gingerbread house, and the courtyard bloomed with thousands of tiny lights. After a minute, they began to twinkle, as if all the stars in he sky had been replaced with blue, green, and red lights. Tucked beneath the clouds of cotton snow, they glimmered like jewels, appearing and disappearing as they winked their bright eyes. At the same time, the elf chorus took up in he middle of "Winter Wonderland", their reedy voices echoing strangely through the empty mall.

I looked to see where my mysterious visitor was, and saw that he was lying in a big fluffy bank of snow, his naked body sprawled as though he were in

the middle of his own bed. His cock was stretching up across his belly, and he was jerking off slowly as he watched me. Going over to him, I sank down into the snow, the cotton soft against my skin. Straddling his chest, I pushed my ass into his face. My balls pressed against his hungry mouth, and he back to suck on them eagerly.

My face hovered above his huge cock as I lay against his stomach, feeling the hair on his body rubbing over my skin and his mouth massaging my nuts one at a time, moving from one to the other. Leaning down, I ran my tongue down the length of his tool, from the tip of the fat head to the soft, hairy place where his balls tumbled into the space between his legs. His thighs were hairy, and my cheeks brushed against them as I rooted in his crotch, savoring the rich taste of sweat and the maleness of his skin.

Moving back up, I took the tip between my lips and sucked at it. I was rewarded with a stream of sticky pre-cum that coated my tongue and slipped down my throat, coating it with the thick taste of his jism. Urged on by this delicious beginning, I slid as much of his cock as I could into my throat, groaning as his thickness swelled inside me, his shaft expanding as his excitement mounted. At the same time, he

moved his mouth from my balls to my ass, slipping his tongue into my crack and finding my sensitive asshole. My prick jumped against his chest as he found his way inside my chute, his tongue forcing its way past my hole as his hands gripped my ass painfully.

As I loosened up, he started to thrust his tongue more deeply into me. I began to match his movements in my ass with those of my mouth on his prick, sliding inch after inch into my anxious throat as he reamed me from behind. After a while, his tongue slipped out of my ass and was replaced by a finger that slid in and out of my slicked opening in time with the dick penetrating my mouth. Soon it was joined by a second, then another and another until four fingers were grinding into my butt, stretching it wide.

Having my ass fucked as I sucked his big cock was an amazing feeling, as if we were connected by a line that ran through the middle of my body. I ground myself fiercely against his hand, sliding my cock against his chest while I tried to push every last inch of his prick into me, loving the way the hair on his body tortured my sensitive cockhead and the way his dick choked me with its size. I imagined how his fin-

gers would look sliding in and out of my hole, what my heated walls must feel like against his skin, and became even more turned on.

I wanted to taste his ass as well, so I let his cock fall from my lips. It lay against my neck as I pushed my hands beneath his knees and pulled his legs back towards his waist. As I leaned my weight on his thighs his beautiful ass spread out before me, the cheeks parting to reveal his fur-rimmed hole with a pink pucker at its center. Diving in, I licked and kissed his hole until the spit-soaked hair swirled in delicate circles around the opening like a wreath. He tasted wonderful, thick and heady, and I wanted to lick him forever. My mouth traveled over the mounds of his beautiful ass, biting at the skin as his balls rolled against my throat and the sounds of the elves singing "Silver Bells" swirled through my head.

His cock was pressing insistently against my throat, and I was overcome by the need to have it inside me. Letting his legs fall back down, I turned myself around so that I was sitting on his chest facing him, His face was bathed in a changing wash of blue, green, and red as the lights around us twinkled. I leaned forward and guided the head of his prick into my waiting hole. As I pushed back, he lifted his

hips and drove his tool deep into my willing ass until I was sitting against his balls, my cock pressed flat against my belly it was so hard.

"A nice tight fit," he said. "Just like going down a well-built chimney."

I couldn't respond, my mind reeling from the size of the dick filling me. It was a good thing he'd loosened me up with his hand first. I felt his head twitch somewhere in my belly and groaned, my ass clamping tightly around his shaft. He put his hands on my chest and once more gripped my nipples tightly, twisting them as I began to ride him in long strokes. When I reached the tip of his cock, he fucked the opening of my chute in short thrusts, sending flutters of pleasure through me as if snowflakes had tumbled onto my bare skin.

Sinking back down the length of him, I was once again filled with his solidness and his heat. My ass swallowed him greedily, feasting on every inch. My cock began to ache as I rode him, and beneath me he started to breathe heavily, working my tits even harder the more I pumped him. The fire inside me reached the point where it threatened to burst into my chest, and I felt my balls tense with the need to release. I started to pump his rod more quickly, antic-

ipating the delicious spread of pleasure I knew would accompany my explosion.

"Don't come," he whispered, just as I was about to blow my load. "I want you to fuck me."

It took everything I had not to spray my spunk across his chest, especially as he gave one final push and I felt him swell inside me and gush streams of heat into my bowels. As I concentrated on holding back the torrent that roiled restlessly in my nuts, his mouth opened in a silent cry as he reached the edge, his tool scattering drops of seed throughout my insides. I felt them plaster my chute in thick waves and held my cock tightly in my hand to prevent myself from shooting.

Pulling out of me, he rolled me off him and knelt on his hands and knees with his head down on his hands. His cock, still hard and slick with his own cum, hung down, fat drops sliding into the cotton snow. All worked up from my own need to come and from feeling him explode inside me, I wasted no time moving behind him and slamming my prick into his delicious ass. My stomach slapped against his butt as I drove my cock to the root with one thrust, my hands tightly clamped on his waist. I thought I might pass out from the sensation that enveloped my

overworked tool, and began to fuck him as hard as I could before I couldn't hold out any longer.

As I worked towards my climax, my head swam with a mixture of heat and the sounds of the manic elves, who had now reached the "Hallelujah Chorus" segment of their repertoire. My cock was sliding in and out of him fiercely as I pumped his beautiful hole, and I wanted it to last forever. Lifting his head, he began to beat his cock in time with me. His ass coaxed my prick to new heights of joy, and I pounded him furiously as the voices of the elves rose up dizzyingly through the chorus of hallelujahs that signaled the song's end.

As they reached the shattering climax, their tinny voices hanging on the last note sharp as an icicle, he and I came together. My prick exploded in rejoice, showering his ass with a snowstorm of cum that roared through him with a wild howl. At the same time, his head flew back and a stream shot from his cock and spattered against the wall of the gingerbread house, where it trickled down like slowly melting snow.

Exhausted, I collapsed in the snow, pulling him down on top of me. The elves, finished with their concert, were quiet as the tape rewound itself somewhere

inside them. The lights twinkled merrily around us, sparkles of color spinning over our sweaty bodies as we tried to catch our breath. Through the skylight, I could see that it was snowing heavily, swirls of white scattering across the glass in frosty eddies. We lay there silently, his softening cock against my leg.

"Looks like it's getting stormy out there," he said. "I should probably be on my way,"

He got up and began to dress, pulling on the red suit as I put my uniform back on. When he was fully costumed, the white beard back in place and the cap on his head, he reached into his pocket. Pulling out a candy cane, he handed it to me. "Merry Christmas," he said as he walked out of sight, "Merry Christmas to all, and to all a good night."

A Queer Christmas Carol

Lawrence Schimel

Part One: Marvin's Room

Marvin Goldstein was dead, to begin with. Of that there was no doubt.

And there was no way for Scott Murphy to forget this fact, especially at this time of year, as one year was drawing to a close and another was about to begin. He remembered the last Christmas he and Marvin had shared, the party they threw with Marvin's friends, in the hospital room, knowing it was to be Marvin's last. Marvin was in rare form that night, kvetching and sarcastic as only a Jewish fag can

be. "Here's something for you to remember me by—literally," Marvin had said, bitter and ironic, and gave all his friends yahrzeit candles as his final Christmas present. Which was characteristic of Marvin's sense of humor, giving a Jewish object—yahrzeit's are part of the Jewish ritual of remembering their dead, candles that burn for days which are lit each year to mark the anniversary of the death—as a Christmas present. He didn't know if any of Marvin's other friends ever lit their candles, but each year, although Scott was not himself a Jew, he lit the yahrzeit to remember Marvin.

He did not light them on the anniversary of Marvin's death, the day itself, in the Christian calendar. Instead, he lit the yahrzeit on Hanukah, the Jewish celebration of lights. Marvin had always hated how commercial Christmas had become; Hanukah was not a major holiday in the Jewish calendar, but because of the secular prominence that Christmas had, Hanukah was elevated, in terms of marketing and packaging, to a greater priority, to have a Jewish counterpart to Christmas.

Each year, Scott would place eight yahrzeits on the windowsill, and like a menorah, each night he would light another candle, until all eight burned.

Yes, Marvin was as dead as a doornail now, thanks to AIDS. And Scott had not had sex since his lover's death, seven years ago.

Not that he hadn't had offers. Why that very afternoon, Christmas Eve day, while working late at the office on a project when everyone else had already gone home to their families and celebrations, one of the assistants had again tried to pick him up. Fred had been after Scott for some months now—never overbearingly, but persistent in his pursuit.

Scott was all but oblivious. Sure, he noticed the attention, and Fred's intentions, but he had long since forgotten how to act in this situation, and more importantly, he had long ago lost the desire to do so, to follow these encounters through to their intense, heated climaxes.

Scott was a man who was afraid of sex. He was afraid of his desires, which were not so frightening as desires went—sexually, he liked men instead of women, a very simple thing.

But Scott no longer had sex—not with a lover, not even with himself. He had so given up any sexual activity, he had now forgotten how to enjoy the intimacy of another body, the slide of skin on skin. He could not even arouse himself.

An erection, for Scott, was nothing more than a bodily quirk these days, something he awoke with each morning. It was not at all sexual, but his body's mechanism to keep him from pissing in his sleep, and once his cock softened to allow him to relieve his bladder, it stayed soft, all day and all night.

And Scott's asshole, which once had brought him so much pleasure, now was clenched tighter than Scrooge's legendary, miserly fists.

Scott was dead to pleasure, and nothing, it seemed, could wake the dead.

Scott had been raised to believe his desire for other men was an abomination, and he could not help but fear for his soul whenever he felt this desire. And what's more, he could not help but fear for his life, for how could he enjoy sex when he was constantly afraid of AIDS?

Scott had managed to overcome his religious upbringing and love men, physically and emotionally. He had put aside his upbringing so totally that he "married" a Jew.

And the price he paid for this love was to bury this lover.

Scott could not face loving another man again, not when he couldn't know if this man was or would

become sick and leave him, as Marvin had. He could not face sex with another man when he couldn't know if that man would infect Scott, accidentally, for they knew so little for certain about this disease. That risk was just too great for him.

When Fred came into Scott's office and said, "I saw the lights on. What are you doing here still on Christmas Eve?" Scott did not hear him until he began to speak.

"You startled me," Scott complained, not quite turning away from his work to look at his visitor.

"Would you like to come to my place for some dinner? I'm spending the Holidays alone myself, and I know I could use the company."

Though sexual tension still lurked underneath the gesture, Fred's offer was simple and genuine enough. He would be happy simply to spend the Holidays with another warm body, even if they did not have sex.

Scott had no use for companionship of any sort any longer.

"I have work to be done, and I don't celebrate the Holidays any longer." He measured the distance between two walls on the page before him.

"Well, a Merry Christmas to you," Fred said,

undaunted, unwilling to give up so easily. "Here's my number in case you change your mind." He wrote on a scrap of drafting paper on Scott's desk, then left the office, leaving Scott alone.

The security guards came through at 10pm and kicked Scott out of the office, so they could close the building and go home to their families. Scott gathered up all the papers on his desk, intending to continue working on them at home. He had a drafting table set up, and would be able to work uninterrupted by the phone or coworkers tomorrow.

At the apartment—a co-op he'd inherited from Marvin—Scott rifled through the mail, an assortment of bills and unsolicited catalogs and advertisements. One catalog, advertising men's underwear, caught his attention for longer than he cared to admit, and the inkling of a memory began to burn within his brain. Scott ignored it. "Waste of trees!" he declared. He gathered up the offending papers, and went out into the hallway, to drop them down the chute to the incinerator.

As he opened the chute's little flap on the wall, however, Scott could swear he saw the face of his dead lover, Marvin, staring back at him. Scott blinked, trying to clear the image from his eyes. He thrust the

papers down the chute as quickly as he could, and slammed the little door shut. The sound seemed to echo through the entire building.

Scott hurried back to his own apartment, and threw the dead bolt once he was safely inside. He stood, panting with an uncommon fear, leaning against the door as he mused upon the image he thought he had seen in the chute. Impossible, of course, for Marvin was long dead; Scott had buried him himself.

Not in a Jewish cemetery; they wouldn't accept the body.

Scott remembered quite clearly, how Marvin had acted out, upon learning his serostatus was positive. "The thing I've always been afraid about with tattoos," Marvin had said, "is that most of the designs I like won't age well. Things I'd regret when I'm sixty or seventy. But that's not a problem now, is it?"

Marvin had gotten a tattoo of a Winnie the Pooh on his biceps, and later a band of geometric designs around his calf, and these kept him out of the Goldstein family's cemetery.

Scott heard a sound behind him, through the heavy door to the building's hallway. It was as if a doorbell were being rung, as if every doorbell in the

building were ringing at the same time. His own bell began to buzz, but Scott ignored it.

He stepped away from the door as he again heard something in the hallway behind him. His buzzer continued to sound. Scott was afraid to look through the peep-hole, as if he might accidentally let whatever was out there into the apartment if he pulled aside the metal shutter to peek through the glass lens.

It didn't matter. Scott watched as whatever was out there making such a racket passed through the heavy door into his apartment.

"Marvin?" Scott said, his voice a whisper. "Can it be you?"

The apparition continued forward, and Scott took a step backward for each that it advanced, until he tripped on the edge of a rug and fell onto the sofa. Marvin—or rather, the ghost of Marvin, for Scott could see right through the image of his dead lover—continued to approach.

"What do you want from me?" Scott cried.

The ghost smiled. "What have I ever wanted from you, dear?" The apparition reached down into Scott's crotch, and the hand passed through the fabric of Scott's clothes to fondle his genitals. "It's been so

long since we've had sex, don't tell me you're not in the mood."

Scott leapt up from the couch and crossed to the other side of the room. He clutched his head between his hands, rubbed at his eyes, not believing what he saw before him.

The ghost sighed. "Please don't tell me you have a headache. Such a tired excuse. After seven years, after I come back from the dead no less, to see you again, don't you think I deserve better than that?"

Scott's head did not merely ache, it felt as if it were about to burst asunder with incredulity and disbelief. What was he to do?

"You doubt your senses," the ghost continued, "because you have not used them to feel anything in so long. But I am quite real, have no fear of that. I am not what you should be afraid of at all."

"What do you mean by that?" Scott demanded. He took a deep breath, calming himself, as he waited for the ghost of his dead lover to answer.

"You are more dead than I am. Just look at you. When was the last time you got laid? Better yet, when was the last time you even jerked off? You're dead as a lump of coal, for all that you're still breathing. No pleasure, no feelings. I've known tombstones with

more human warmth than you give off."

"How charming. You came all this way to harangue me for my sexual habits. What's the matter, not getting enough ten feet under? Serves you right for all the times you cheated on me when we were together!" Scott tried to turn away from the ghost, but found he could not quite turn his back to the phantasm; some part of him still feared his dead lover's upset ghost, and some part of him, too, hungered for ever last vision of him, even if Scott was positive this was a hallucination.

"Still so petty, I see. Nice to see some things don't change. We wouldn't want any emotional growth, now would we?" The ghost heaved a great sigh. "I didn't come here to have a fight. I came to tell you that you are wrong. I came to warn you, so that maybe you can change your future."

"What are you talking about? What do you know about my future."

"My time is short, so I'll cut to the chase. Dickens got a lot of things right. Only I'm a Jew, so let's forget about Christmas. Instead, let's teach you about your dick. You remember the story, I'm sure: three ghosts, starting when the clock strikes One."

Marvin's ghost stood.

"But wait," Scott began. "I—"

"You had your chance," Marvin said, meaning so much. "I've pulled some strings to get you a second one. Don't mess up. Use it or lose it." The ghost turned away from him, then turned back. "And that applies to both the second chance and your dick."

And with that, Marvin disappeared.

Scott crossed back to the spot where Marvin had been standing. "He was just here," he whispered, hardly believing it was true. "His ghost was just here," he muttered, correcting himself.

Scott was afraid to go to bed. He brewed a pot of coffee. He would stay awake and greet the ghosts with a cup of coffee for each (they could at least smell the aroma even if ghosts couldn't drink liquids anymore). He would show them he wasn't afraid of them (especially since he knew they were coming).

But then he changed his mind and poured the coffee down the sink. He was more afraid not to follow the rules of the story. He brushed his teeth and flossed them, staring at himself in the mirror. He wasn't as inhuman as Marvin had said he was. Was he?

Scott pulled on his flannel pajamas, and double-checked the deadbolt on the front door before climbing into bed. He left the bedside light on—just in case.

A thumping sounded from against the wall he shared with his neighbors. At first, Scott was afraid it was another ghostly presence, having arrived early. But then a woman's voice cried out, a howl that hovered between pain and ecstasy, and he realized it was just the woman next door having sex with her latest boyfriend. She went through a new one each month, more or less, because she wore them out so quickly.

"I'll never get to sleep now," Scott muttered, knowing from past experience that she could go on for hours. He wondered, for the first time in a long time, exactly what they were doing on the other side of the wall...

And, still musing on those images, Scott fell asleep.

Part Two: Sowing Wilde Oats

His alarm clock went off, but Scott tried to ignore it. He was in the middle of some dream—he didn't quite know what it was, just that he was certain it was something he wanted to keep dreaming, just a little while longer. Then he could get up and go to work.

"I suggest you do something about that infernal

racket," a voice to his right said.

Scott bolted awake and upright, staring about the bedroom. A man stood over his bed. Scott rubbed sleep from his eyes. The man looked like a young-ish Quentin Crisp. Only Crisp wasn't dead yet, Scott was pretty sure, so his ghost couldn't be standing in Scott's bedroom.

No, it wasn't Crisp, Scott decided as he stared more closely at the stranger. Just someone with his same outdated (not to mention outlandish) fashion sense. The face was plainer, more rounded, almost owlish.

The stranger was unfazed by Scott's mute appraisal. "The machine to your left, I believe, is what you're looking for."

Scott stared at the alarm clock on his nightstand, which increased its insistent buzzing as the timer continued to tick, then turned back to the stranger in his apartment.

The visitor rolled his eyes, and exasperatedly demanded, "Silence that contraption already!"

Scott jerked alert and hit the snooze bar.

"Thank you," the ghost said. He moved around to the other side of the bed. "May I?" he asked, indicating the chair.

"Sure," Scott said, wondering what he'd eaten that gave him multiple hallucinations like this. Or, as Marvin might've complained: What have I done to deserve this?

Whatever it was, he still had to deal with the here and now.

Scott stood up. He didn't like feeling so out of control of the situation, so helpless. "So," he said, sitting on the edge of the bed, directly across from the spirit. "You must be the Ghost of Christmas Past."

"Indeed, you impudent pup."

Scott waved his arms. "Pish posh, old man. Let's get on with it, shall we? What have you got to show me?"

"There was a time you showed more respect of your elders," Oscar Wilde's ghost said, sternly. Scott could not help staring into the ghost's eyes, feeling himself lost in them. "Or have you forgotten?"

The room about him faded black. He could see nothing but the old man's face, his eyes, his dark hair spreading outward and seeming to envelop him in a cocoon.

Scott blinked, and when he opened his eyes he was standing in the Mineshaft. The ghost stood beside him, looking completely out of place, with his

foppish scarves and billowing sleeves, amid the machismo clones and leather daddies who prowled the bar's darkened rooms.

The phantasm nodded toward one corner, and Scott turned to follow the ghost's gaze. With a start, he saw a younger version of himself, not even twenty yet, down on his knees before a trio of older men. His hands were cuffed behind his back. Each of the men wore chaps, with nothing on underneath; their heavy balls and cocks dangled before his young face. A harness crossed the wide chest of one of the men; the other two wore leather vests. The young Scott was sucking off one of the men, hungrily wolfing down his swollen cock, while the others stroked themselves and watched, awaiting their turn. The young Scott let the cock drop from his mouth to catch his breath, but one of the other two grabbed him by his hair and pulled his head toward their crotch, guiding their dick into his warm mouth.

Scott watched, amazed at his younger self's eagerness, his willingness to service these men, to do their bidding. He had hungered for their attention, for the way they forced themselves on him. He begged for it, and these men, these Daddies made him beg, made him voice each plea.

Scott felt someone cop a feel through the flannel of his pajamas, and glanced away from the escapades of this younger version of himself. An elaborate lace ruffle brushed against his leg as the hand was withdrawn from his crotch. Scott looked up at the ghost, to express umbrage at the liberties that had been taken, when he realized that he had an erection. He'd gotten hard from watching his younger self blow that trio of older men.

"Pity an old man?" the ghost asked Scott, mockingly, while fumbling with the fastening of its trousers.

Scott opened his mouth to protest, but no sound came forth. He looked back to the corner where his younger self groveled before three men in their late forties and early fifties, men who, at the time, had seemed impossibly old to Scott.

"Yes," the ghost said, as Scott watched one of the men prepare to fuck his younger self up the ass while another continued to thrust into his mouth, "we remember now the respect that is due to our elders. Look at me when I talk to you, Boy."

Almost against his will, Scott's head swiveled— drawn by the ghost's power, and also by the authority in that command, by the memory of days when he

desperately craved being in the hands of someone who would tell him what to do, someone he felt he could trust, who would protect and nurture him. Scott stared into that ghostly face, a face he could almost see through, as if it were a smoky pane of glass—a face whose eyes were a window onto another world, the world of Scott's past, the things he had done in his wilder youth.

"No," Scott said, and turned away from the ghost's eyes.

The scene around them had changed. They were in his first Manhattan apartment, years before he'd met Marvin, which he'd shared with three other young gay men, all of them newly moved to the Big Apple from the Midwest. Kevin was from Ohio, and Jordan and Edward were both from Kansas.

"You cannot escape from the pleasures of the past," the ghost reminded him.

Scott could not forget.

He knew what scene would unfold before them now. That first Christmas in the apartment together, the four of them threw a wild and raucous party for all the friends, tricks, and lovers they'd made since moving to that urban gay mecca.

Scott watched, unable to turn away, as old friends

got drunk and slowly began shucking their clothes. He couldn't help wondering how many of these men were still alive. He hadn't thought about them in so long.

Soon, they were all naked, nearly twenty men in their twenties, having sex in a wild, messy heap.

Scott watched as this younger Scott threw himself with abandon into the frey, losing himself in the madding crowds, the press and crush of bodies and cocks, of willing mouths and asses. His younger self was intoxicated with pleasure, thrusting his cock into any nearby hand or orifice. He watched the young Scott come, time and again, in some youth's mouth or ass. And even when his cock was too tired to rise again, the young Scott continued to play with the men around him, greedily sucking on their limp cocks, trying to coax life back into them.

"Yes, those were the days, the glory days of yore," Scott said, turning to look at the ghost who stood beside him. "The glory hole days of yore," he quipped. "But they're gone now."

"Yes," the ghost whispered, as the world faded black around Scott once more. "They're gone now. But you cannot pretend that they never were."

"I don't—" Scott began, but he silenced himself as

he knew his protestations were untrue. He turned away from the ghost's black eyes, but the world stayed dark. "Ghost, where are we now?" Scott cried out.

But as his eyes adjusted to the dimness, Scott knew where they were, as he had known the apartment they had just revisited, and he felt a dread foreboding in the pit of his stomach. They were in the showers of the Chelsea Gym, years later. In many ways, not so very different from the bathhouses he used to visit: a roomful of naked men, saunas, showers, sex. But the situation was different.

Scott knew what scene was to unfold before him. This was the trendy, fashionable gym, where Scott worked out three times each week, back when he still cared enough about his body to put effort into it. When he cared about his body but had grown afraid to use it.

For months, as he worked out, he had lusted after one dark-skinned latino man, with broad shoulders that tapered to a slim waist, a classical V-shaped torso. Scott didn't know the man's name, but he knew that body so well, had memorized every curve and shadow of it. In his mind, he had taken his pleasure from that body— for in those days Scott still took pleasure

183

from his body. But only alone, always alone. He was afraid of other men, though he wanted them, desperately craved them.

On this day which unfolded again before Scott's eyes, though he tried to block out the visions, to lose himself in the steam and mist—to no avail—this man who he had lusted after for so very long, who quite literally had become the man of his dreams, sat next to him in the steam room.

The vision-Scott's dick began to fill with blood at the mere proximity of his idol.

And his idol took notice. The man reached down and held the vision-Scott's thickening cock in his dark hand.

Scott's own cock stood at attention as he watched, again, the beginnings of this scene he had imagined so many times. Scott had jerked off to this scenario for months, hoping and praying, but never quite believing this day might come true.

And when it actually did happen, Scott was afraid. His mind had rushed forward, to those images of sex with this man that he had fantasized so many times before. But presented with the real thing, the man himself, his body touching Scott's, was too terrifying for him. The pressure of the man's fist around his

cock felt wonderful, but that feeling was not enough to combat the overwhelming fear that made Scott's dick go soft. Scott gently lifted the man's hand off his dick, smiling ruefully.

The latin man shrugged, and turned to the man sitting on the other side of him, who'd grown hard watching Scott and Latin play. Scott watched, aghast, as the man of his dreams slipped through his grasp, hating himself for letting this opportunity disappear. He could not stop watching as these two men groped each other, fondling crotches, tweaking nipples, nibbling the flesh of each others' arms and necks.

They did nothing "unsafe." Scott could as easily have been doing these same, "safe" things with this man.

But he was afraid.

Afraid of sex. Afraid of intimacy. Afraid of pleasure.

The price of fear was regret, eternal and everlasting. He would always remember having had this opportunity, and having botched it out of fear.

Regret, his sole companion of his advancing age.

"No," Scott cried out. "No. No!"

He awoke, in his bed, as he sat bolt upright. His cock spasmed again. Cum squirted against the inside

of his pajamas, which were tented out in front of him from his erection. His pubic hair was matted down with ejaculate.

"No," Scott whispered still. He did not want to face his fears. It was easier for him to ignore sex.

But he stared down into his lap. Could he ignore sex again, after what he'd been shown? Could he ignore sex again, now that he remembered?

His groin was suffused with the pleasurable afterglow of release.

But he was also sticky with his own cum and sweat, all that messiness of sex.

He stood up and went into the bathroom. He cleaned himself off, pulled on a dry pair of pajama bottoms, and climbed back into bed.

Part Three: (Saint) Nick

Scott woke with the knowledge that he had just finished a dream, though he did not remember what it was. He lay in bed, eyes still closed, and thought about the events of that evening. Without opening his eyes, he reached out and pressed the snooze button, for he knew that even though the alarm was not set, the clock would buzz at two am and rouse him. Scott

had always been good at waking a few minutes before the alarm went off, to spare himself its shrill tones.

He listened to the darkness of the room about him as he lay in bed, wondering who the next ghost would be, and when it would appear. Scott realized he could hear something, a sort of fizzing sound, like an alka seltzer in water. He wondered if it was the ghost, already.

"Might as well wake up and find out," Scott muttered.

He rolled onto his back and threw the covers off of him. He had a piss-erection, he noticed, though he'd taken a leak just before getting into bed an hour ago, when he'd awoken after the last ghost's visit.

He didn't feel like he had to take a piss again. But he did reach down and feel his hard cock, marveling at how good it felt simply to hold his erection in his hand, and trying not to think about how long it had been since he'd last done so.

A bead of pre-cum stained his pajamas, where his cockhead pressed up against the fabric. The rough cotton felt so good sliding against the sensitive glans.

"I see we've taken a head start on things," a voice said from the foot of the bed. "Or should I say a hand

start." The voice laughed.

Scott looked up, and saw that the television was on. There was no station, just static—the crackling, fizzing sound that had woken him—and an image of a naked man, who was talking to him.

While Scott had become, over the last seven years, insensitive and impervious to sex and sexual pleasure, he was not completely unaware of the sex going on around him. So he recognized the naked man on his television screen, as the first truly-famous porn star bottom: Joey Stefano.

"Bring that over here, Big Boy, and I'll give you a helping hand myself."

It was a corny line, Scott knew, but not many men were propositioned like that by an internationally popular porn star. Someone Scott had actually jerked off to, back in the days when he was still masturbating, if not having sex with other men.

There was something intoxicating about being approached sexually by this man so many men had desired. But at the same time, he wondered if a ghost could infect a person with HIV.

What harm could it do? Scott thought, as he stood up and walked to the television set. He unbuttoned his fly as he walked, and pushed his erect cock so that

it poked between the folds of fabric.

"That's my Boy," Joey Stefano said, reaching out from the television set to grab hold of Scott's cock. He squeezed the shaft, sending shivers down Scott's spine, and then tugged Scott by his dick into the television set.

They were now both the same size, in a small hallway.

"Pleased to meet you," Stefano said, shaking Scott's dick, which he still held. "You can call me Nick. All of my friends do." Scott remembered hearing about Joey's real name after his suicide. Nick Iacona, that was it. There was a whole book about him now, he'd seen it in the window of a porn store he passed on his way home from work—though, of course he had not stopped to examine it.

"I can't believe I'm talking to you." Scott looked down at his dick, still being squeezed in Nick's palm. It felt like it belonged to someone else for all the connection he felt to it. "I can't believe I'm doing this with you. I have friends who would kill to be in my place right now." He thought how he could make a killing from people he knew, who'd pay exorbitant sums for the chance to be where he was now.

"Actually, most of your friends are having enough

fun on their own. Look for yourself." He pointed behind Scott.

They were staring out of a television screen at Scott's co-worker, Tim. The glass was like a window, through which they could look out at Tim's bedroom.

"He can't see us," Nick said.

"I can't believe this, you're a ghostly peeping tom! We both are."

"We're peeping Tim, in this case," Nick corrected. "Peeping at Tim's pee-pee."

Scott couldn't help glancing out at the organ in question. Tim was masturbating, completely naked on his bed as he pulled his pud with one hand, the other massaging his ass.

"I think this is more information about Tim than I wanted to know."

Tim had a small dick. Much smaller than average. Which was surprising to Scott, who had just assumed that Tim's prick matched the rest of his large, over-muscled body. He began to wonder if Tim had used steroids, which were said to make one's genitals smaller.

"Why are we watching him?" Scott asked. Not that he could stop himself; he was mesmerized by his

co-worker's actions, comparing it to how he would jerk off. He grabbed his own dick, as if for reassurance. "If I'm supposed to get off from these visions, wouldn't it be better to show me some well-hung stud?"

"Anyone can find pleasure in their bodies," Nick said. "Besides, it's in the script."

"The script?" Scott asked. He looked at the ghost, and suddenly realized he was talking with the Ghost of Christmas Present, and all the rest of the story. "Oh, I get it, now." He struck his forehead with one palm. "I can't believe I walked into that. Tiny Tim."

Scott stared out of the television set at his coworker. Then he turned and looked over his shoulder, and saw they were in a porn set. "Hey, you're in here twice," he said, tapping Nick on this shoulder.

Behind them, Joey Stefano was lying on his back on a picnic table, getting fucked by Ryan Idol.

"I know," Nick said. "Tim's got good taste."

Scott kept looking back and forth, between the scene on the picnic table and the one outside the television set. Tim had pulled a dildo from under the bed, and was using it now to fuck himself as he watched the screen and jerked off with his other hand.

Scott's hand was moving in time to Tim's, he realized suddenly, and for a moment he felt as if Tim were watching him jerk off, not the other way around. Scott was the star, the hot body that everyone lusted after, that Tim, with his small dick, was fantasizing about at this very moment.

Nick slapped Scott across the butt, hard. "Wake up. You're taking this all wrong. You need to learn to take it," the ghost said, "up here." He shoved a hand between the cheeks of Scott's ass, pressing upward.

Scott woke up, as ordered, in his own bed again. But not without one last image of Tim through the television's screen:

Tim was happy as a clam, despite his tiny prick. He screamed and shouted with pleasure, not caring what the neighbors might think as he reveled in the sensations flooding his body. His cum was shooting onto his stomach, pooling in his belly.

Scott's own stomach was slick with semen. Another wet dream, from this second ghost.

He reached down and pushed his wet pajamas down. He ran his fingers through the drying jism, smearing it over his body. He didn't quite have the abandon he'd seen in Tim, thrashing about on the bed, but Scott was enjoying himself. Which is, he

thought, what the ghost had wanted him to learn.

He lifted his hand to sniff the cum-soaked fingers, and then put them in his mouth. For the first time in years he tasted cum, his own cum, still safe, but reminding him of how much he'd liked the taste of cum, its sweet/salty funk.

Scott left his pajamas on this time, and slightly-sticky, rolled over and drifted happily to sleep, one hand clutching his warm, softening cock.

Part Four: Last Offering

Scott stirred as Marvin lifted the covers and climbed into bed beside him. The ghost snuggled up beside Scott, wrapping his arms around his lover. It felt so comfortable, Scott almost believed it was a decade ago, when Marvin was still alive, still felt so real as he did right then. Scott didn't want to do anything to break this moment. But he also couldn't help wondering.

"What happened to The Ghost of Christmas Future?" Scott asked, half-asleep.

"I am the ghost of your future," Marvin said.

"And I am the ghost of your future," a second

voice said. Scott looked up, startled by this newcom-
er. There stood Steven Willis, the first boy he had ever
fooled around with, wrestling by the lake at camp
one summer and accidentally touching each other's
cocks, and deciding they liked it, and touching them
again on purpose.

"And I am the ghost of your future," a third voice
said. Robert Sutton, his boyfriend from college.

"And I," said the voices, one after another, as every
man Scott had ever made love to, had ever dated, had
ever sucked off in some tearoom or back alley, had
ever fucked or been fucked by, claimed him again.

"But you can't all be dead!" Scott cried. "I know
you're not all dead. Eric, I got a Christmas card from
you last week, even if I did I throw it out. You can't
have died between now and then. I didn't even know
you were sick!"

"I'm not dead," Eric said, "but I am a ghost of
your future. Every time you have sex, you remember
all the other men you've had sex with."

"You cannot escape from your past," Marvin said,
"nor should you try to. Whenever you make love to
another man, I will be with you. And, through you, I
will again enjoy the pleasures of life that are now
denied me."

"You abstinence denies not only your own pleasure, but ours as well. We are the ghosts of your future," they cried in unison, every man he had ever loved before, as they climbed into bed with him and ran their fingers, mouths, and cocks across his body.

Scott screamed.

It was too much for him—too much sensation, too much pleasure, too much everything.

But the ghosts did not stop. Voracious and insatiable, they licked and stroked him, holding him down as he struggled beneath them, trying to break free.

His cock was swollen with exertion and excitement, almost despite himself. He did not want to be aroused right then, did not want to be having sex.

But he had no choice. The ghosts took their pleasure from his body, making up for seven long lost years of enforced vicarious abstinence.

They teased and caressed his body, stroked and and petted, pulled and tweaked.

At last, they let him come—a blindly overwhelming orgasm that knocked him and his overworked senses senseless.

When he awoke, daylight shone through the window. It was Christmas Day. He was naked, atop his

bed. White droplets of semen splattered his chest and stomach. "A white Christmas," Scott muttered, and smiled.

He lay on his bed, trying to make sense of his memories of last night, then got up and showered. He got dressed and went down to the street.

The city was trying to close down all sex establishments—the peep shows and buddy booths, the erotic video arcades and burlesques. Scott used to approve of these measures, feeling that such things didn't belong in public, so garish and obvious and present. Sex was something for people to do behind closed doors, if at all.

But his attitudes about sex had changed now. Or rather, changed back, to the way he used to feel.

Scott was glad the city had not succeeded in its attempts to shut down the porno shops, as he headed to the one located two blocks from his apartment. It was open, even on Christmas, for all the dissatisfied and lonely souls, needing some quick release on this stressful day.

As Scott entered the XXX-EMPORIUM, he decided to draft plans for a more-upscale pornpalace. Part of the city's problem, Scott thought—aside from the fact that these stores acknowledged that sex, and especial-

ly queer sex, existed—was the cheap, no-frills, sleazy way in which they presented and promoted themselves and the entertainments they contained. But if these stores were repackaged, Scott wondered, would they stand a better chance of staying alive?

It was worth a try, Scott thought. Even if his plans didn't work, they might get people thinking. It would be his way of contributing to the fight to keep these stores from being forced to close.

Scott bought a dildo to give to Tim—Tiny Tim, he couldn't help recalling, and laughing at the irony of it all. The dildo was easily four times the size of Tim's own cock, but that wouldn't bother him at all, Scott was sure. Tim was a piggy little bottom, Scott knew from having watched him masturbate, and his eyes would light up when he unwrapped this Christmas gift.

He wondered if he'd use it with Tim sometime. Back when Tim first joined the office, he'd hit on Scott, and Scott had, of course, ignored him at the time.

Now, he wondered what it might be like. He considered sex with Tim, even with his tiny prick. Scott was pretty much a bottom, although he was afraid of getting fucked these days, even with a condom. But

Tim had fun during sex, that was obvious. Maybe they could have fun together, two bottoms in bed. And, of course, Scott did sometimes like to fuck, and as he stood in the pornshop with his newly-awakened sexuality, he felt like he wanted to try everything again.

But thoughts of Tim could wait until later, Scott realized, as he bought the store's largest bottle of lube and a box of condoms for himself. He brought his purchases back to his apartment and put them on the small table just inside the hallway. Scott sat down at his drafting table and rifled through the papers he had brought home to work on that day. At last, he found what he was looking for, and reached for the phone.

"Fred? It's Scott Murphy. Merry Christmas! I was wondering if that offer you made last night was still open..."

About the Contributors

Tom Caffrey is the author of the collections *Hitting Home And Other Stories* and *Tales from the Men's Room*, and his stories have appeared in numerous magazines and anthologies, including *Advocate Men*, *Freshmen*, *Mandate*, and *Wanderlust*. He lives in San Franciso.

M. Christian is the author of *Dirty Words* (Alyson) and editor of various anthologies, such as *Eros Ex Machina* (Masquerade). His stories have appeared in *Best Gay Erotica 1996*, *Best American Erotica 1994*, *Southern Comfort*, *Happily Ever After*, *Noirotica*, and other anthologies. He lives in San Francisco.

Jameson Currier is the author of the novel *Where The Rainbow Ends* (Overlook) and a collection of short sto-

ries, *Dancing on the Moon* (Viking). His fiction has been anthologized in *Best Gay Erotica 1996* and *1997*, *Men on Men 5*, *All the Ways Home*, *Certain Voices*, and *Man of My Dreams*. He lives in Manhattan.

Lars Eighner is the author of the bestselling memoir *Travels With Lizbeth* (St. Martin's). He is also author of *Pawn to Queen Four* (St. Martin's), *Gay Cosmos* (Hard Candy), *Bayou Boy* (Badboy), *B.M.O.C.* (Badboy), *American Prelude* (Badboy), *Whispered In The Dark* (Badboy), and *The Art of Arousal* (Richard Kasak). He lives in Texas.

Christopher Marconni's stories have appeared in *Torso* and other magazines. He lives in Ohio.

Felice Picano is the author of *Like People In History* (Viking), *The Lure* (Hard Candy), *Men Who Loved Me* (Hard Candy), *Ambidextrous* (Hard Candy), and other novels. A member of the Violet Quill and founder of the Seahorse Press and Gay Presses of New York, he now lives in Los Angeles.

Matthew Rettenmund is the author of the novels *Boy Culture* (St. Martin's Press) and *Blind Items* (St. Martin's

Press), as well as *Encyclopedia Madonnica* (St. Martin's Press) and *Queer Baby Names* (St. Martin's). His stories have appeared in numerous magazines, as well as the anthologies *Wanderlust, Best Gay Erotica 1996, Southern Comfort, The Mammoth Book of Gay Erotica,* and *Switch Hitters: Lesbians Write Gay Male Erotica and Gay Men Write Lesbian Erotica,* among others. He lives in Manhattan.

Leigh W. Rutledge is the author of *Gay Decades, The Gay Book of Lists, The Diary of a Cat, Cat Love Letters, Dear Tabby, The Lefthander's Guide to Life,* and *It Seemed Like A Good Idea at the Time,* among others. His work is also featured in the *Flesh and the Word* series and *The Badboy Book of Erotic Poetry.* He lives in Florida.

Lawrence Schimel is the author of *The Drag Queen of Elfland* (The Ultra-Violet Library), a collection of queer science fiction stories, and *His Tongue* (Frog Ltd.) a collection of his gay erotica. He has edited more than twenty anthologies including: *The Mammoth Book of Gay Erotica* (Carroll & Graf), *Switch Hitters: Lesbians Write Gay Male Erotica and Gay Men Write Lesbian Erotica* (with Carol Queen; Cleis Press), *Two Hearts Desire: Gay Couples On The Love* (with Michael Lassell; St. Martin's Press), *Kosher Meat* (Sherman Asher), *Boy Meets Boy* (St. Martin's

Press), and *Things Invisible to See: Gay and Lesbian Tales of Magic Realism* (The Ultra Violet Library), among many others. His stories, poems, and essays have appeared in more than 160 anthologies, including *Best Gay Erotica 97 and 98*, *The Random House Book of Science Fiction Stories*, *Weird Tales from Shakespeare*, *Gay Love Poetry*, and *The Random House Treasury of Light Verse*, among others. He has also contributed to numerous magazines, ranging from *Saturday Evening Post* to *Physics Today* and *Drummer*. He is thirty years old, and divides his time between his native Manhattan and Madrid, Spain.

Simon Sheppard is the author of *Hotter Than Hell and Other Stories* and the forthcoming nonfiction book *Kinkorama*. He's also the co-editor, with M. Christian, of *Rough Stuff* and *Roughed Up: More Tales of Gay Men, Sex, and Power*, and his work has appeared in over 80 anthologies, including the *Best American Erotica*, *Best Gay Erotica*, and *Friction* series. He loiters at www.simonsheppard.com.

About the Editor

David Laurents is the editor of numerous best-selling anthologies, including: *Wanderlust: Homoerotica Tales of Travel* (Badboy), *Southern Comfort* (Badboy), *Rough and Ready* (Zipper), *Feeling Frisky* (Prowler), *Overload* (Zipper), and *Hard at Work* (Zipper). His collection *The Badboy Book of Erotic Poetry* (Badboy) was a finalist for the Lambda Literary Award. His erotic short stories and poems have been published in many magazines, including *Drummer*, *Torso*, *Mandate*, *First Hand*, *Steam*, and *Gay Scotland* as well as in various anthologies, including *Flashpoint*, *Sportsmen*, *My Three Boys*, *Mad About the Boys*, *In The Boy Zone*, *Coming Up: The World's Best Erotic Writing*, and others. He lives in New York City.

Acknowledgements

If you enjoyed "Stocking Stuffers," you might also enjoy some of the other fine publications from Circlet Press, Inc.

Wired Hard 2: More Erotica for a Gay Universe, $14.95
Explore masculinity and the desire of men for men through the lens of otherwordly settings and characters. With stories by Mason Powell, David Laurents, Gary Bowen, and more.

Wired Hard 3: Even More Erotica for a Gay Universe, $14.95
Includes the work of Simon Sheppard, Gary Bowen, Jack Dickson and more.

Queer Destinies, $5.95 by Gary Bowen
Five short stories of fantastical gay male erotica.

The Drag Queen of Elfland, $10.95 by Lawrence Schimel
Gay and lesbian fantasy stories from this critically acclaimed writer.

Add $4 shipping and handling for the first book, $2 for each book thereafter, for shipping within the US/Canada. Send VISA/Mastercard information, or check or money order to:

Circlet Press, Order Dept. SS
1770 Massachusetts Avenue #278
Cambridge, MA 02140

or visit www.circlet.com